MASTERPIECES OF CHINESE ART

RHONDA AND JEFFREY COOPER

ABOUT THE AUTHORS

Rhonda Cooper has been Director of the University Art Gallery at the State University of New York at Stony Brook since 1983. An adjunct lecturer in Stony Brook's Department of Art, Ms. Cooper received her MA in the History of Far Eastern Art from the University of Hawaii and currently teaches courses in both Asian art history and gallery management at Stony Brook. She previously taught Asian art history at the University of Bridgeport and the Art Institute of Boston and was curator of Asian Art at The Dayton Art Institute. Ms. Cooper lives on Long Island, New York, with her co-author husband and their daughter Sara.

Jeffrey Cooper is a freelance writer and editor. His books include several novels for teenagers and middle-readers, three film novelizations, and a humorous guide to intergalactic romance.

MASON CREST

MASON CREST
450 Parkway Drive, Suite D
Broomall, Pennsylvania 19008
(866) MCP-BOOK (toll free)

Printed and bound in the United States of America.

First printing
1 3 5 7 9 8 6 4 2

ISBN (hardback) 978-1-4222-3936-0
ISBN (series) 978-1-4222-3930-8
ISBN (ebook) 978-1-4222-7858-1

Cataloging-in-Publication Data on file
with the Library of Congress

PICTURE CREDITS

5, 18-19, 56-57, 58, 68, 70, 74, 75, 79, 82, 83, 84, 88-89, 90, 91 (top),
 92, 102, 103, 106, 110, 112, 123 National Palace Museum, Taibei

6, 10, 27, 39, 62, 65, 71, 76-77, 80, 104-105, 107 Nelson-Atkins
 Museum of Art, Kansas City, MO

8-9, 26, 33, 66-67 Seattle Art Museum

11 Buffalo Society of the Natural Sciences, Buffalo, NY

12, 14, 16 (bottom), 21, 22, 23, 59, 81, 100, 101, 115, 117
 Freer Gallery of Art, Smithsonian Institution, Washington, D.C.

13, 16 (top), 20, 43, 55, 113 Giraudon/Art Resource, NY

13, 16 (top), 20, 28-29, 34, 35, 36-37, 38, 42, 43, 44, 45, 49, 52, 55, 60,
 63, 64, 85 (top), 94, 98-99, 111, 113, 122 (top) Art Resource, NY

15, 114 Sen'oku Hakkokan (Sumitomo Collection), Kyoto, Japan

17, 31, 48, 86-87, 93, 108, 109, 116, 118, 119, 122 (bottom)
 Metropolitan Museum of Art, New York

24-25 Minneapolis Institute of Arts

28-29, 34, 35, 36-37, 42, 44, 45, 49, 60, 94 Erich Lessing/Art Resource

30, 32 Cleveland Museum of Art

38, 63, 98-99 Werner Froman Archive/Art Resource

46, 120-121 Asian Art Museum, San Francisco

47, 91 (bottom), 96 Dennis Cox/China Stock

50 Agence Photographique de la Reunion des Musees Nationaux

51, 77, 78 Museum of Fine Arts, Boston

53, 61, 125, 126-127 British Museum, London

54 University Museum, University of Pennsylvania, Philadelphia

64, 111 Victoria & Albert Museum, London/Art Resource, NY

73 Percival David Foundation of Chinese Art, London

72-73, 85 (bottom) Tokyo National Museum

85 (top) Scala/Art Resource, NY

FRONT COVER ILLUSTRATION

FIVE-COLORED PARAKEET ON A BRANCH
OF A BLOSSOMING APRICOT TREE
Museum of Fine Arts, Boston

BACK COVER ILLUSTRATION

YOU, RITUAL WINE VESSEL IN FORM
OF BEAR SWALLOWING MAN
Sen'oku Hakkokan (Sumitomo Collection), Kyoto, Japan

Cover design by Mark Weinberg/Command-O

CONTENTS

INTRODUCTION

Ding, Ritual
Food Vessel

Shang dynasty, Anyang period,
c. 1300–1050 B.C.E.; bronze;
32¼ in. high x 23 in. diameter
(81.9 x 58.4 cm). National
Palace Museum, Taibei.
The *ding* ritual vessel,
with its round body
and three legs, was
used to hold an offering
of cooked food. A
series of stylized animal
masks are arranged in
a single horizontal
band that accentuates
the shape of the vessel.
Additional animal
masks decorate the legs.

The Western world has long been fascinated by all things Chinese. Many Westerners, however, have found their appreciation of Chinese art to be somewhat limited by their unfamiliarity with the ancient cultural traditions that permeate Chinese civilization. For some people, the result has been a frustrating inability to distinguish among the numerous bronze vessels, colorful ceramics, and elongated paintings of mist-enshrouded mountains that they have encountered in their museum visits. The intent of this chronological survey of Chinese art masterpieces is to provide some basic background information to enhance the reader's enjoyment and appreciation of the diversity and virtuosity of Chinese art.

China is the third largest country in the world and home to more than one-fifth of the world's population. With the Siberian steppes to the north, tropical jungles to the south, vast deserts to the west, and 2,500 miles (4,022 kilometers) of coastline to the east, China is a land of vast geographic and climatic diversity. The numerous mountain chains that dot the Chinese landscape divide the country into distinct northern and southern regions, each with its own geographical features and cultural traditions. The richest farmland lies in the fertile plains and valleys of the Yellow and Wei rivers to the north and the Yangzi and Xi rivers to the south, and it is near those rivers that China's great cities first arose.

Throughout China's long history, ambitious rulers from both inside and outside the country's borders have attempted with varying degrees of success to consolidate and control this vast and culturally diverse land. While each ruling house took its place on the stage of history, snatching power from its predecessor before being inevitably overthrown in turn by its successor, native artists gradually perfected the various styles of metalwork, ceramics, sculpture, and painting that have come to be recognized as distinctively Chinese.

Continuity has been a consistent theme of Chinese civilization. Despite a tumultuous history of bitter civil wars and foreign invasions, Chinese culture has survived for thousands of years by maintaining a persistent respect for the past and a keen awareness of the past's connection to both the present and the future. The Chinese people's reverence for ancestors, their strong sense of history, and their remarkable capacity for blending innovation and tradition have all contributed to keeping Chinese culture intact in times of adversity.

Written language has also played an important role in maintaining the continuity of Chinese civilization. Despite regional differences in pronunciation, the pictographic characters that make up the Chinese written language have remained essentially unchanged since their first appearance more than three thousand years ago. Whether painted with a brush or cut into stone, the same basic system of writing has been used continuously for thousands of years to record and preserve the history and traditions of the Chinese people. The art of calligraphy has traditionally been regarded as the highest of all Chinese art forms. Mastery of the brush, whether used to write a poem or paint a picture, is recognized in traditional Chinese culture as the hallmark of the educated person.

The materials and techniques used for the practice of calligraphy and painting are essentially the same. The finely pointed Chinese brush is held in an upright position so that the tip of the brush—generally made of goat's hair—is centered over the writing surface. The ink, which is made from water, pine soot, and glue, is molded into cakes called ink sticks that are then rubbed with water on

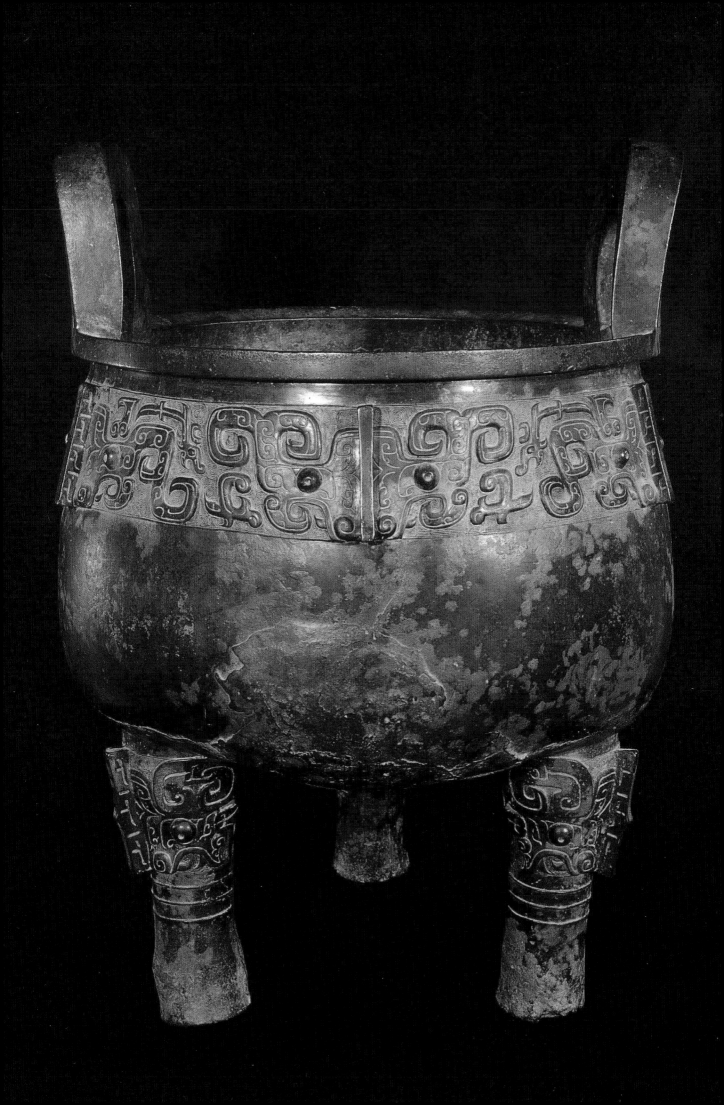

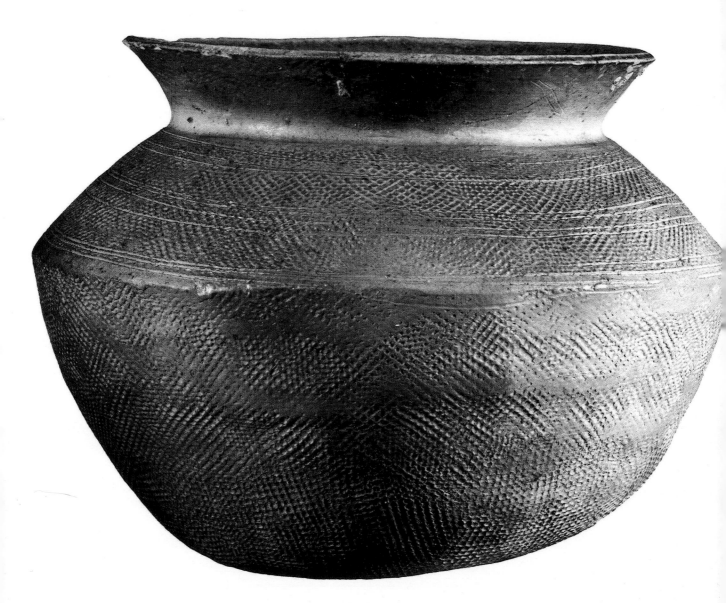

Guan Jar

Probably from Zhengzhou, Henan province, Shang dynasty, 16th to 15th
century B.C.E.; glazed stoneware; 6⅛ in. high (15.5 cm). Purchase:
Nelson Trust, The Nelson-Atkins Museum of Art, Kansas City, Missouri.

This high-fired, ash-glazed jar represents the earliest type of glazed
stoneware in China. The pale, olive-colored glaze provides a
glassy coating that both seals and decorates the thinly potted jar.

the flat sloping area of an inkstone. Prior to the invention of paper, which is traditionally dated to the year 105 C.E., Chinese painters and calligraphers painted mainly on strips of bamboo or on silk, which was first cultivated in China over four thousand years ago; indeed, the ancient Romans called China the "Silk Lands," and the great trading network that conveyed Chinese silks, ceramics, and other goods across Asia to the Mediterranean was known simply as the Silk Route.

Chinese paintings are traditionally mounted either as hanging scrolls or handscrolls, both of which were usually kept rolled for storage. The vertical hanging scroll, which was used for figure painting and large-scale landscapes, was intended to be viewed simultaneously by a large group of people. The horizontal handscroll format sometimes interspersed paintings with narrative text and was designed to be viewed one section at a time by individuals or small, intimate groups. Collections of smaller paintings in circular, oval, rectangular, or fan shapes were often pasted into albums that could be spread out and viewed all at once or viewed as individual pages in a book. Chinese paintings often include a poem or other inscription by the artist, and art collectors sometimes added their own inscriptions, called colophons, to the paintings they collected. The red seals included at the end of the inscriptions are the signature seals of the artists and collectors.

Despite their seeming contradictions, Daoism and Confucianism together provided the philosophical underpinnings of traditional Chinese culture. While Confucianists focused on the individual's duty to conform to the rules of a rigidly hierarchical social order supported by a clearly defined code of moral behavior, Daoists embraced spontaneity and nonconformity in their effort to live in harmony with the indescribable Way known as the Dao. The mystical metaphysics of Daoism and the sober authoritarianism of Confucianism found common ground, however, in their shared concern with living life in harmony and balance. Later, when Buddhism was brought to China from abroad, the Chinese gradually filtered the foreign religion through their native sensibilities and, ultimately, put a new Chinese face on it. The subtle evolution of Chinese Buddhist art as it gradually distanced itself from its Indian origins provides a graphic illustration of the Chinese talent for incorporating innovation into the seemingly rigid confines of tradition.

To understand Chinese culture, it is necessary to understand how the traditional Chinese view of mankind's position in the universe differs from that of the Western world. In China, heaven, earth, and man were perceived of as links in a great cosmic chain, with the emperor—the Son of Heaven—serving as mediator. In China, nature has traditionally been understood to operate through an ever-shifting balance of *yin* (characterized as dark and passive) and *yang* (characterized as light and active). Where Westerners tend to see a world of contradictory and irreconcilable forces in constant conflict, the Chinese see a subtle interplay of complementary elements gracefully shifting this way and that to maintain their natural balance. In the Chinese worldview, negative and positive are not opposite but complementary— together, *yin* and *yang* give form to the One of which all things in nature, including mankind, are equally a part.

This book uses the official Chinese phonetic alphabet called *pinyin*, rather than the older Wade-Giles system, to romanize Chinese characters. Thus, the city once called Peking is now rendered *Beijing*, the Ch'ing dynasty becomes the *Qing*, and the religion of Taoism is spelled *Daoism*, which is how it was pronounced all along.

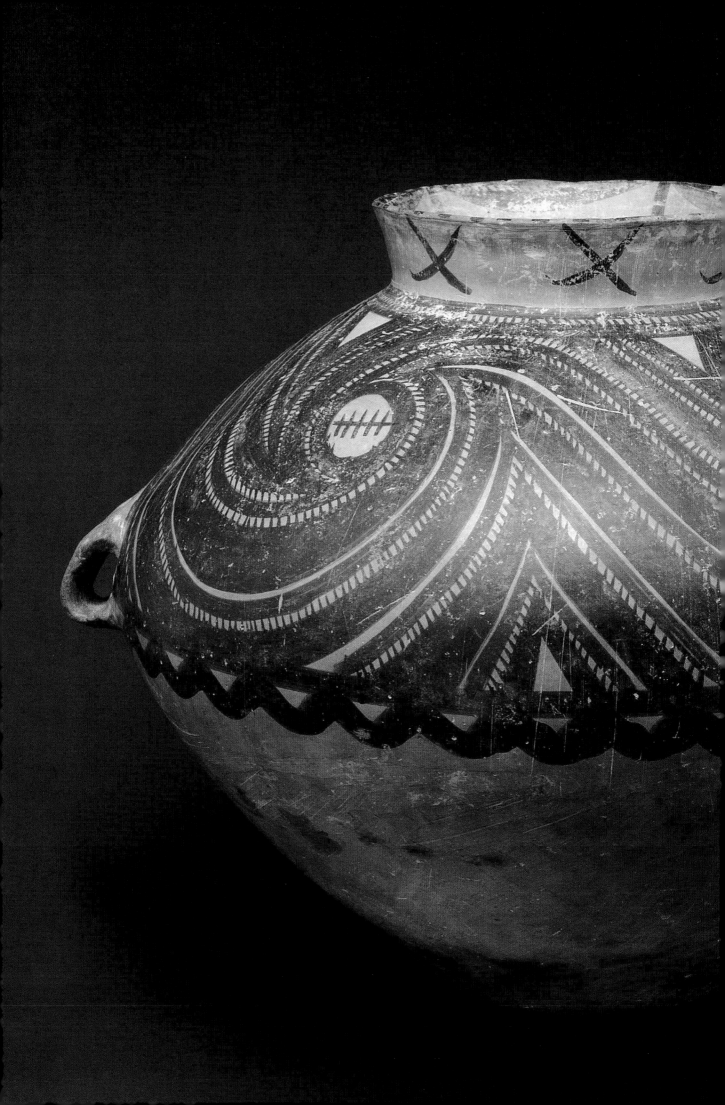

FROM STONE TO BRONZE

The story of Chinese art begins more than six thousand years ago in the Neolithic villages that arose as people settled down to domesticate animals and till the fertile land of the Yellow River valley and the Yangzi delta. While the various people who inhabited China's great landmass left no written accounts of their lives, extensive archeological excavation of thousands of sites throughout China have revealed a great deal about the surprisingly sophisticated technology of the Neolithic Chinese cultures as they slowly moved from the Stone Age to the Bronze Age.

The Neolithic Period (c. 5000 – c. 1700 B.C.E.)

Unlike their contemporaries in Europe, the inhabitants of Neolithic China showed little or no interest in carving or wall-painting; instead, they

Burial Urn

Yangshao (Painted Pottery) culture, Banshan, Gansu province, Neolithic period, c. 2200 B.C.E.; red earthenware painted in black and red slip; (14⅛ in. high 35.8 cm). Seattle Art Museum.

The thinly-potted ovoid shape, typical of Banshan burial urns, is painted with a bold, linear spiral motif in red and black. The design is confined to the upper portion of the pot, suggesting that it may have been set into the soil for stability.

directed their creative energies to the making of earthenware and finely crafted stone tools and decorative objects. The earliest examples of Neolithic Chinese pottery came with the discovery of the Painted Pottery culture that arose along the Wei River at Banpo in Shaanxi province.

The early inhabitants of Banpo—part of which is now preserved as a museum of Neolithic culture—did not use a potter's wheel to produce their wares; rather, they coiled long strips of clay to make their coarse gray or red pottery. The resulting thin-walled wares were sometimes decorated with geometric—or, less frequently, zoomorphic or anthropomorphic—designs that were painted with black or black and red pigments. A coating of white slip, which is a fluid suspension of clay or other substances in water, was sometimes applied beneath the paint. Clay was also used to make many objects intended for everyday use, although bone was the preferred material for making needles, fishhooks, spoons, and arrowheads. The Painted Pottery culture slowly expanded eastward to Yangshao in Henan province and, later, westward to Banshan and other villages in Gansu province. The magnificent black and red painted pottery unearthed at these sites, dating back to the third millennium

B.C.E., included burial urns, deep bowls, and tall vases with loop handles.

The Black Pottery culture, first discovered in Longshan in Shandong province, arose in eastern China around 2500 B.C.E. Unlike the coiled pottery of the older Painted Pottery culture, much of the black-bodied earthenware that characterized this culture was formed on a slowly turning wheel. Wood or bamboo tools were used to decorate the unpainted wares, which were polished before the clay was fully dry. The resulting thin-bodied wares were then fired in a reducing atmosphere—that is, smoke was introduced into the kiln chamber to reduce the amount of oxygen present, which affected the iron in the clay and gave the ware its characteristic black or dark gray coloring. Typical wares from Longhan include straight-sided pots, tall-stemmed cups, and beakers of the type called *gu*. The people of the Black Pottery culture also made implements of bone and stone. Archeological evidence suggests that they wove cloth and baskets as well, although no examples of either of these have survived.

In addition to the spectacular wares that were presumably produced for ritual use by the Painted Pottery and Black Pottery cultures, potters of Neolithic China made many kinds of gray earthenware bowls, urns, and jugs for everyday use. Notable among these is the *li*, a cooking vessel with three hollow legs.

Neolithic Chinese people used polished stone to make axes, scrapers, and various farming implements. Jade, which was prized for its durability, exquisite colors, and smooth polished surface, was used to make beautiful bracelets, rings, discs, and other decorative objects. Too hard to be easily cut, jade was ground by using an abrasive such as quartz powder. The extraordinary jade objects created by Neolithic craftsmen are a testament to their technical sophistication and remarkable patience. Whether these painstakingly crafted objects had already begun to assume for these Stone Age people the symbolic and ritual associations that they would ultimately acquire cannot be known for certain. What is known, however, is that many of the shapes and decorative motifs that first appeared in Neolithic times would continue to be used and adapted by Chinese artists for thousands of years to come.

Bird

Neolithic period; jade;
2¼ x 1¾ x 1⅛ in.
(5.7 x 4.4 x 2.8 cm).
Purchase: Nelson Trust,
The Nelson-Atkins Museum
of Art, Kansas City, Missouri.
Jade, a hard and brittle stone that comes in a variety of exquisite colors and can be polished to a smooth finish, has long been treasured in China. This sculpture, which conveys the abstracted essence of a bird, was made by a slow and painstaking process of abrasion using sand or quartz grit.

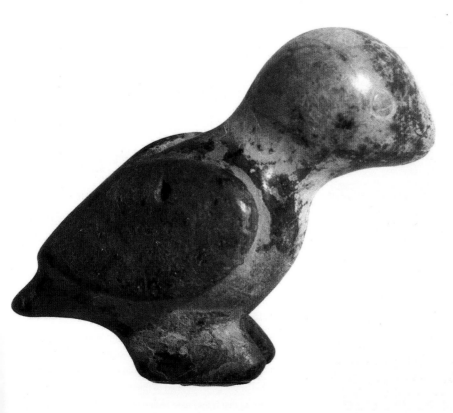

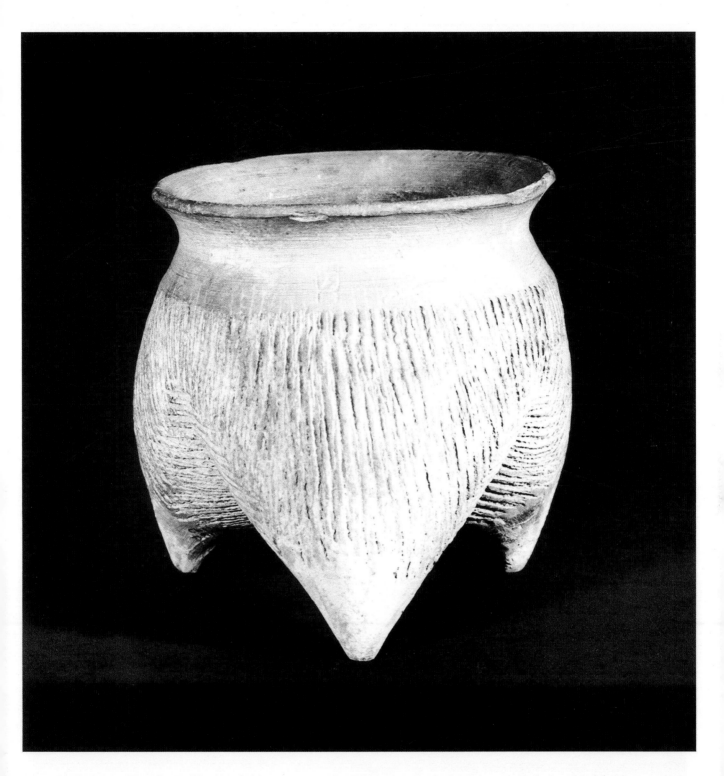

Li Tripod

From Anyang, Henan province, Neolithic period; earthenware; 6 in. high (15.2 cm).

Buffalo Society of the Natural Sciences, Buffalo, New York.

The stable tripod shape of this *li* cooking vessel, with its hollow legs and
bulbous body, would later be used in bronze vessels intended for ritual use.
The cord-impressed pattern was pressed onto the surface before the clay hardened.

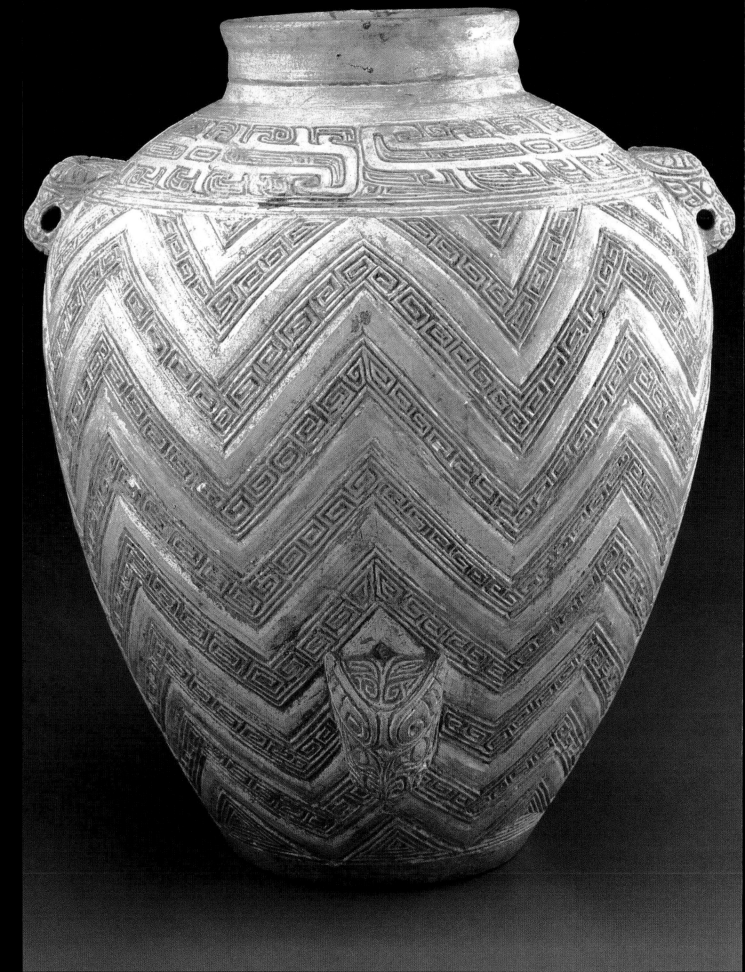

The Shang Dynasty
(c. 1700 – c. 1050 B.C.E.)

For centuries, farmers at Anyang in Henan province had been unearthing notched and inscribed tortoise shells and animal bones (referred to as "dragon bones"), which they sold to apothecaries to be ground up as medicine. It was not until Chinese scholars began examining these bones at the very end of the nineteenth century that they were recognized as oracle bones that were used by ancient people to foretell future events. In their ongoing search for these valuable objects, local farmers began to unearth ancient bronze vessels, jade carvings, and other objects as well. Unwittingly, they had stumbled upon the ancient royal tombs at Anyang, the last capital of the then-presumed-legendary Shang dynasty.

Systematic excavation of some three hundred tombs discovered at this site soon made it abundantly clear that the Shang dynasty of ancient legend had been very real indeed. Little was known about this ancient culture, however, until archeologists unearthed a previously unlooted royal tomb containing hundreds of bronze ritual vessels, carvings of jade, stone, and bone, and an assortment of utilitarian objects presumably intended for use in the afterlife. More recently, archeological discoveries in Henan province have strongly suggested that the legendary Xia dynasty, a Bronze Age culture said to predate the Shang, was almost certainly real as well.

The abundance of artifacts unearthed at Anyang and other sites paints a surprisingly detailed picture of the Shang civilization. Building on the artistic traditions and technological innovations of their Neolithic predecessors, the people of the Shang culture developed a written

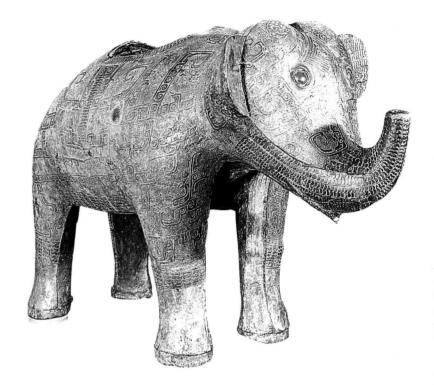

Jar

From Anyang, Henan province, Shang dynasty; white
earthenware with impressed decoration; 13 in. high (33 cm).
Freer Gallery of Art, Smithsonian Institution, Washington, D.C.
The surface of this jar, one of the few intact white earthenware vessels found at Anyang, is covered with elaborate relief decorations, including the low-relief squared-spiral "thunder pattern" and animal masks in high relief, that echo the decorative motifs used on bronze ritual vessels of the same period.

language, a highly centralized government headed by a king who was believed to possess divine powers, and sophisticated bronze and ceramic technologies.

At Zhengzhou, which is believed to have been the second of several Shang capitals, archeologists found the remains of workshops in which ceramic, bone, and bronze objects were produced. Shang potters had discovered that certain materials could be melted at high temperatures to form a glaze and that this glassy coating on the surface of a ceramic ware could be used both for decoration and to seal the clay surface. The most treasured of Shang ceramics are the rare fine-grained unglazed white wares made from a clay that is closely related to kaolin, the main ingredient of the hard, translucent porcelain wares that would not be perfected until the seventh century. While many shards of white earthenware have been unearthed at Anyang, only a few whole pots of this type have so far been found.

Sculpting in stone appears to have been of little interest to the Shang people. Three-dimensional sculptural pieces surviving from this period, which include jade amulets as well as human and animal figurines, were typically quite small. Extremely

Elephant *Zun*

Shang dynasty; bronze;
38 in. long (96.5 cm).
Musée Guimet, Paris.
Craftsmen of China's Bronze Age often made ritual wine vessels in the shape of animals or birds. Elephants may have ranged as far north as the Yangzi valley in the second millennium B.C.E.

difficult to work with, jade was usually carved in thin slabs, although small, three-dimensional figurines were also produced. Among the very few larger sculptures surviving from the Shang period is a marble sculpture of an owl that was found in a tomb at Anyang. Like the proto-porcelain found in the same region, this stone sculpture in the round was decorated with incised linear designs that echoed the motifs typically used on bronze ritual vessels.

While bronze—an alloy of copper and tin and, sometimes, lead—was used by the Shang ruling class for weapons and hunting implements, farmers continued to use tools made of stone, wood, and bone until the introduction of iron many centuries later. Invaluable for making weapons, bronze was also used in combination with jade to make beautiful ceremonial implements. Thin jade blades were often combined with bronze handles, sometimes inlaid with turquoise, to make ceremonial and funerary objects that are far too fragile ever to have been intended for any utilitarian purpose. Bronze was also used to make the ritual vessels that held offerings of food and wine for the ancestors and other spirits upon whose intercession the people relied for good fortune in their earthly affairs.

Bronze ritual vessels produced during the early years of the Shang dynasty were characterized by their simple shapes and thin walls, with thin relief lines and narrow bands of decoration. Over time,

Ceremonial Implement

Shang dynasty; jade blade set in bronze with turquoise inlay; 8½ in. high (21.5 cm). Freer Gallery of Art, Smithsonian Institution, Washington, D.C.

This blade, a replica of a bronze weapon, is far too fragile to have been used for any utilitarian purpose. Jade blades and scepters may have served as emblems of rank in the imperial court.

You, Ritual Wine Vessel in Form of Bear Swallowing Man

Shang dynasty; bronze; 12⅞ in. high (32.7 cm). Sen'oku Hakkokan (Sumitomo Collection), Kyoto, Japan.
This unique covered ritual wine vessel depicts a man clutched by a bear-like beast with a deer on its head and a *kui* dragon on its side. The elaborate surface decoration and the combination of animal motifs is typical of Shang bronze vessels.

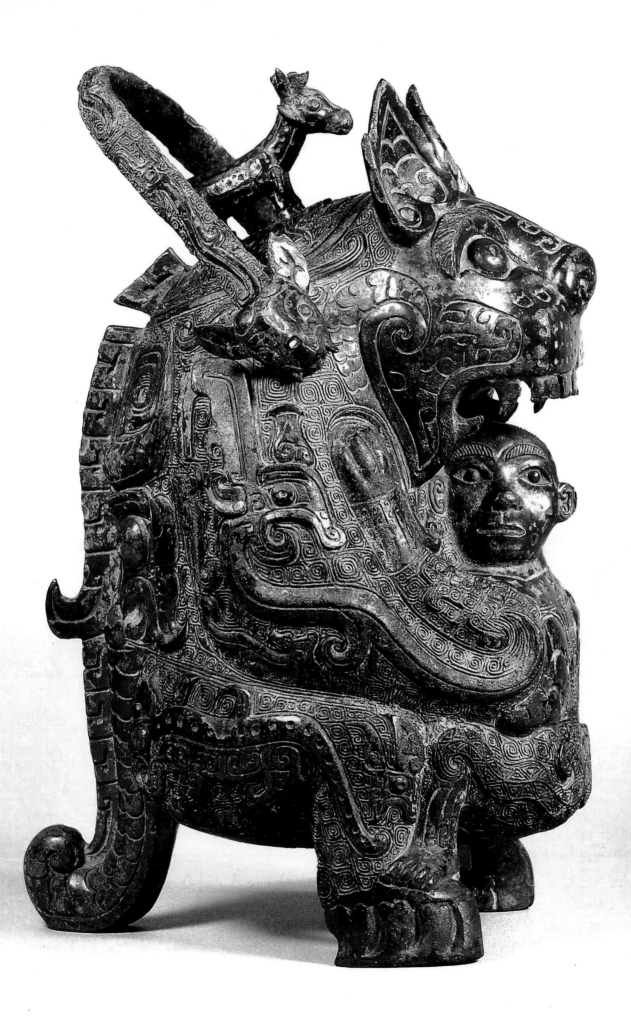

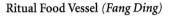

Ritual Food Vessel *(Fang Ding)*

From Ningxiang Xian, Hunan Province, Shang dynasty,
14th to 12th century B.C.E.; bronze; 15 in. high (38.1 cm).
People's Republic of China/Photographie Giraudon.
Decorated on all four sides with a human
mask motif, this ritual vessel bears the in-
scription "large grain." The enlarged flanges of
the rectangular *ding*, which was used to hold
cooked food, are typical of late Shang bronzes.

Guang, Ritual Wine Vessel

Shang dynasty, Anyang period; bronze;
12¼ in. long (31.1 cm). Freer Gallery of Art,
Smithsonian Institution, Washington, D.C.
This unusual ritual wine vessel
combines the head of a grinning
tiger, an owl mask on the lid, and a
bird whose neck forms the handle
into a single, functional design.

the walls grew thicker and the bands of decoration widened. Two decorative motifs that appeared early in this period were the *kui* dragon and the *tao-tie*, a symmetrical mask motif characterized by prominent eyes and decorative elements based on various animal features. While the iconographic significance of the *tao-tie* is not known, the motif proved to be highly adaptable and was used frequently throughout the Shang period.

Shang innovations included the "thunder pattern" (a background pattern of squared spirals reminiscent of the Greek key-fret pattern), the introduction of raised decoration (first in low relief and later developing into high relief with ornamentation projecting into space), and an increased use of real, rather than composite, animal motifs. Regional stylistic variations appeared for the first time in the later years of the Shang dynasty. Several new types of bronze vessels, decorated with both composite and real animal forms, appeared at this time as well. Although these bronze vessels were originally a shiny copper or silver color, the colorful blue or green surface patina caused by corrosion is now considered to be part of the aesthetic appeal of these ancient objects.

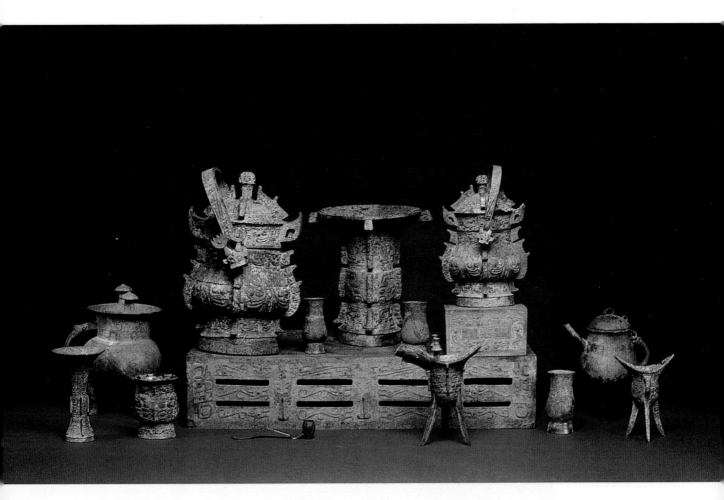

Altar Set of Ritual Food and Wine Vessels
Late Shang-early Zhou dynasties; bronze. Munsey Fund, 1931, The Metropolitan Museum of Art, New York.
Although it cannot be known for certain how these vessels were originally arranged, corrosion outlines of the three principal vessels etched onto the surface of the table suggests the arrangement pictured. These pieces, which were made in different foundries, probably represent the accumulated wealth of a family shrine.

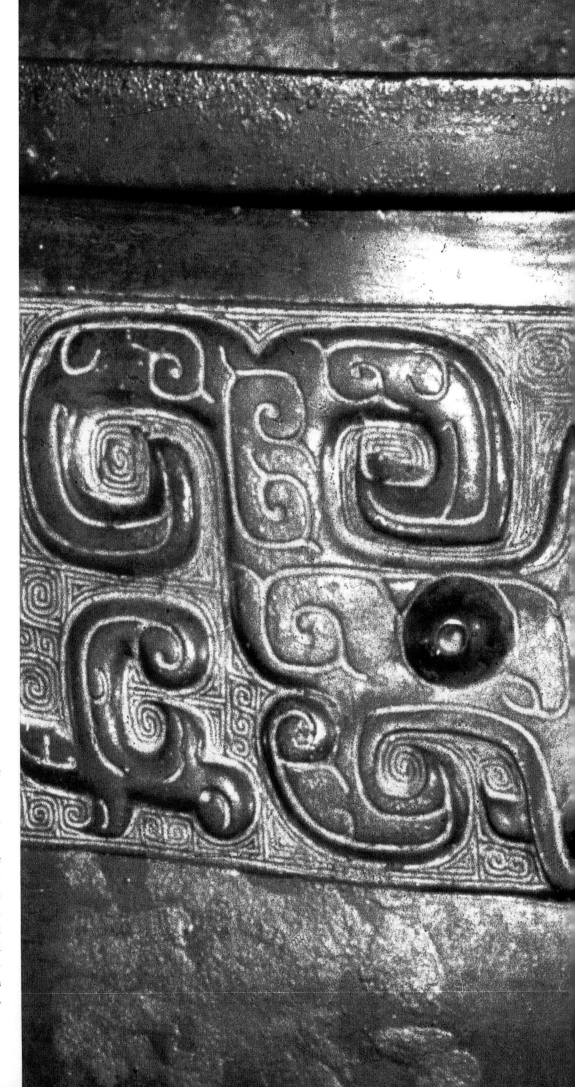

Ding, Ritual Food Vessel

detail; Shang dynasty, Anyang
period, c. 1300–1050 B.C.E.; bronze.
National Palace Museum, Taibei.
Set against a "thunder
pattern" of squared spirals,
the symmetrical *tao-tie*
animal mask is made up
of a variety of zoomorphic
facial elements, with an
emphasis on the raised
eyes. It can also be viewed
as two confronting horizon-
tal creatures in profile with
clawed feet and upturned tails.

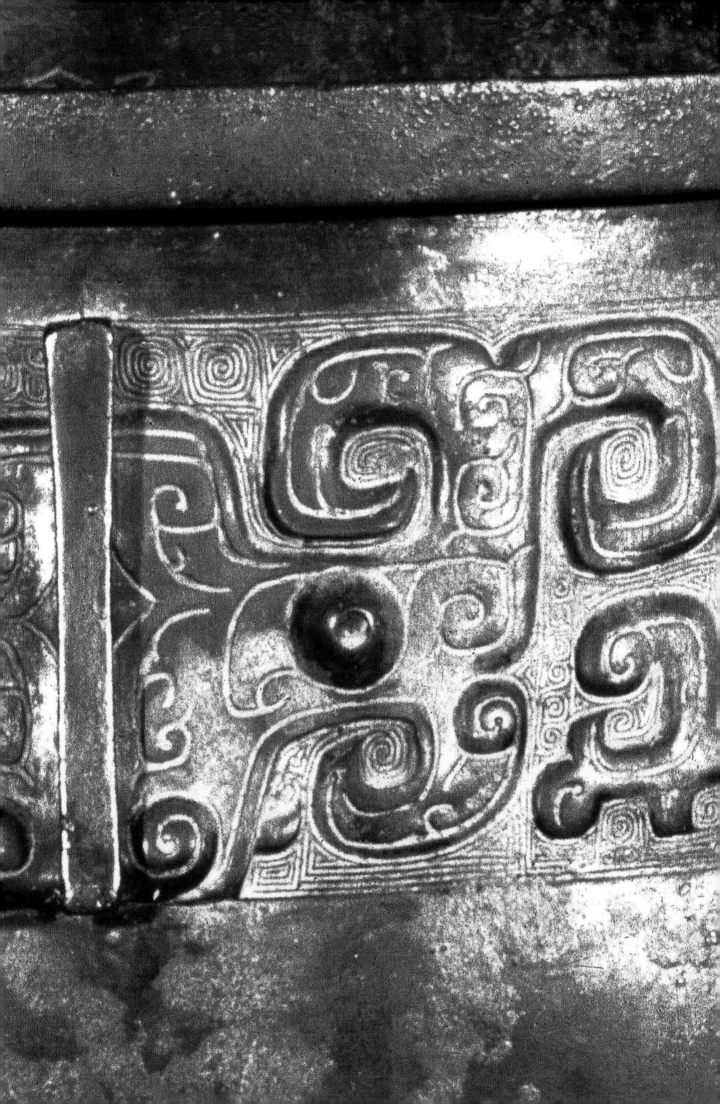

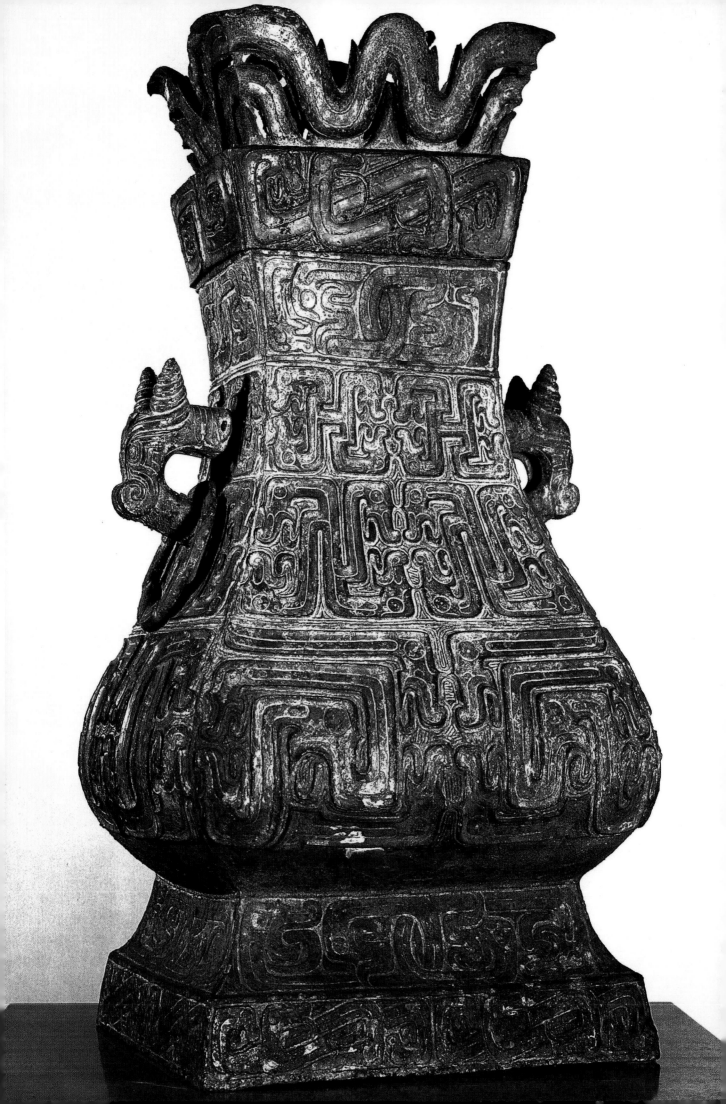

Zhou Dynasty (c. 1050 - 221 B.C.E.)

Around the middle of the eleventh century B.C.E., the Shang dynasty was overthrown by invaders who called themselves the Zhou. The Zhou absorbed and adapted much of Shang culture, including their language and their bronze technology. While the earliest Zhou bronzes continued the same shapes and decorative techniques favored by Shang artisans, several significant changes soon took place: Certain traditional types of vessels were no longer made; the symmetrical *tao-tie* mask that had featured so prominently among Shang decorative motifs was now seen only in the very small masks that sometimes appeared on the handles and sides of vessels; long inscriptions that recorded secular achievements and honors began to appear inside some of the bronzes; an elegant long-tailed bird appeared for the first time as a motif on both bronzes and jades; and jade animal figurines became smoother, simpler in form, and less ornate than their Shang predecessors.

By the middle Zhou period (c. 900–c. 600 B.C.E.), more radical changes in the design of bronze vessels were taking place. New vessel shapes appeared, and ornamentation grew simpler and

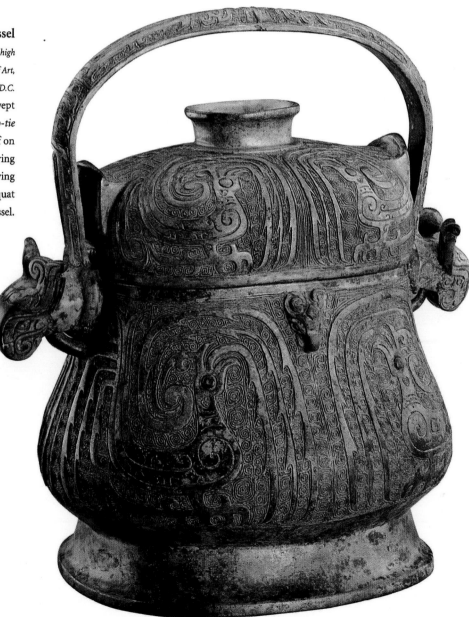

You, **Ceremonial Wine Vessel**

Early Zhou period; bronze; 9 in. high (21.6 cm). Freer Gallery of Art, Smithsonian Institution, Washington, D.C.

The motif of birds with upswept tails replaced the Shang *tao-tie* mask as a decorative motif on some bronzes and jades during the early Zhou period. The flowing lines of the tails echo the squat and rounded form of this vessel.

Hu, **Ritual Wine Vessel**

Middle Zhou period; bronze; 28 in. high (71.2 cm). Musée Guimet, Paris.

This large ritual wine vessel was made to be buried in the tomb of an important person. By the middle of the Zhou period, abstracted geometric forms had largely replaced the mythological or naturalistic animal motifs favored by earlier craftsmen.

more austere. Ornate decoration gave way to horizontal grooving, and the vestigial *tao-tie* mask handles were replaced by plain rings or were completely eliminated. Vessels of this period were generally heavier and squatter than their Shang counterparts, and some vessel types assumed more sculptural forms. Animal-shaped vessels tended to be depicted in a more naturalistic manner with simpler, less fanciful surface decoration. The decoration on a bronze tiger, for example, more closely resembles actual tiger stripes than a stylized amalgam of animal forms.

Among the jade objects produced in great numbers during the middle Zhou period were the *bi*, a ritual disc that symbolized heaven, and the *cong*, a decorated square tube pierced with a circular hole that symbolized the earth. Jade animal figures, especially birds and fish, were also popular at this time.

In 771 B.C.E., the Zhou were forced from their capital at Xi'an and driven eastward. The next several centuries were characterized by warfare and constantly shifting alliances, and it was during these troubled times that both Confucianism and Daoism took root in China. As new social and religious rituals evolved, artistic traditions began changing as well. Bronze decorative motifs became more elegant and complex, and both the *tao-tie* mask and the motif of animal metamorphosis regained popularity. Small, three-dimensional animal figurines, which were sometimes used in burial rituals, and anthropomorphic sculptures in the round began to appear with greater frequency during the late Zhou period (c. 600–221 B.C.E.).

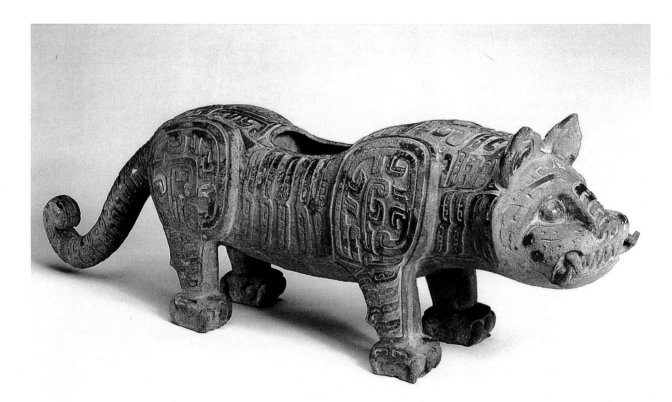

Pair of Tigers

Middle Zhou period; bronze; 29⅝ in. long (75.2 cm). Freer Gallery of Art, Smithsonian Institution, Washington, D.C.

Too heavy to have been used as vessels, these figures were probably not employed for any ritual function. The
openings in the backs of the tigers suggest that they may originally have served as supports for a throne or canopy.

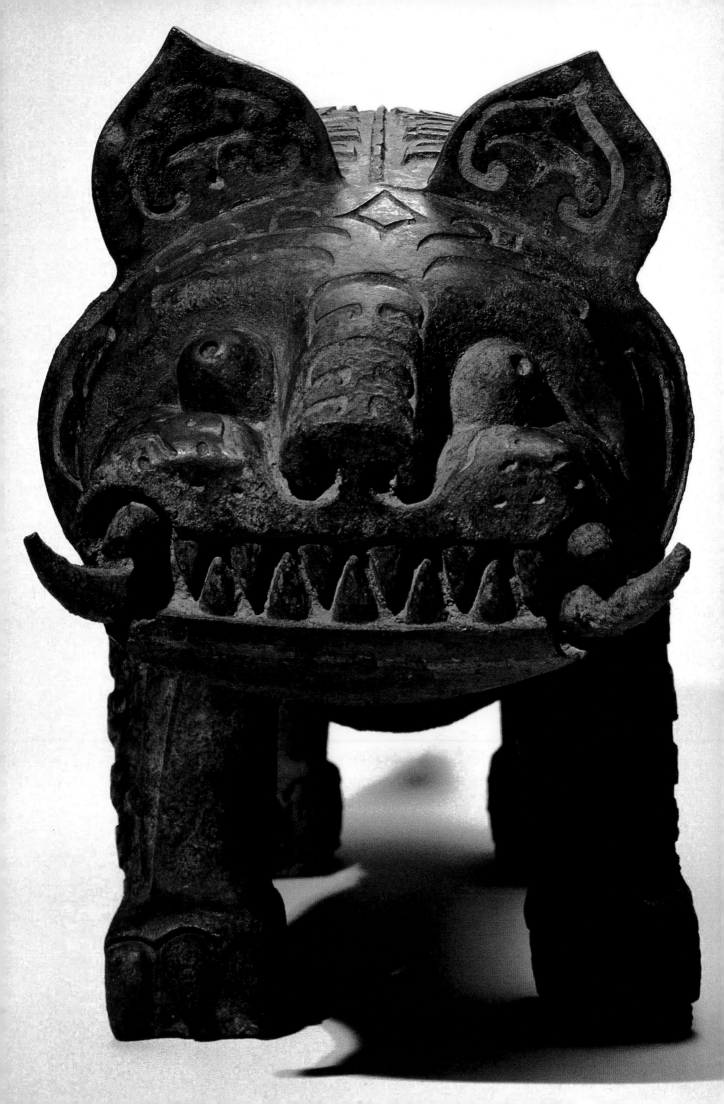

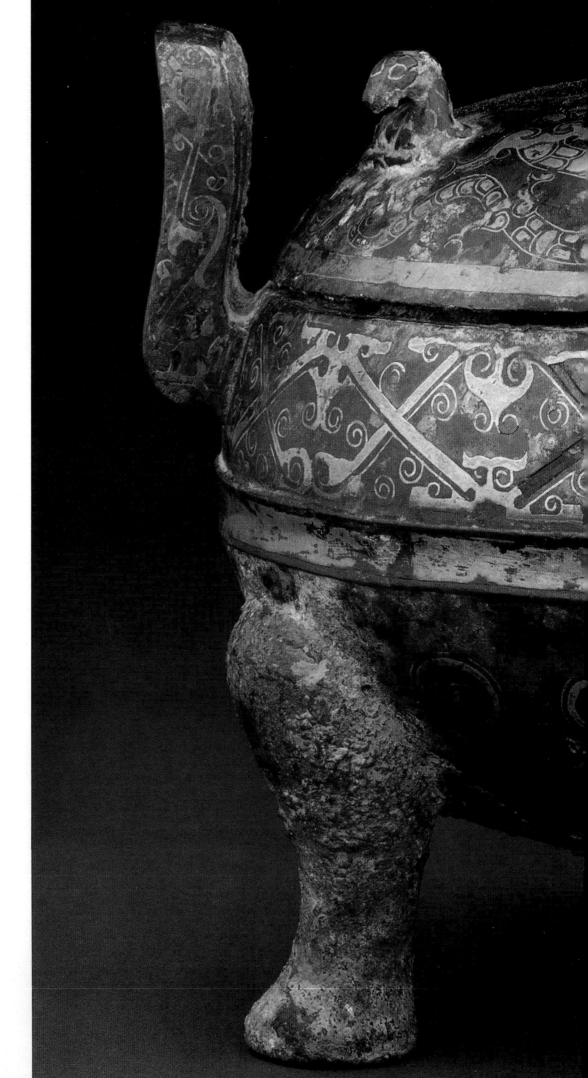

Ding, Ritual Vessel

*From Jin Cun, Henan
province, late Zhou period;
bronze, inlaid with gold
and silver; 7⅛ in. diameter
(18.1 cm). Pillsbury Collection,
Minneapolis Institute of Art.*
The geometric pattern
of intertwined gold and
silver inlays enlivens
the surface of this ritual
vessel. The reclining
rams sculpted in the
round on the lid serve
as legs when the cover
is turned upside down
to function as a plate.

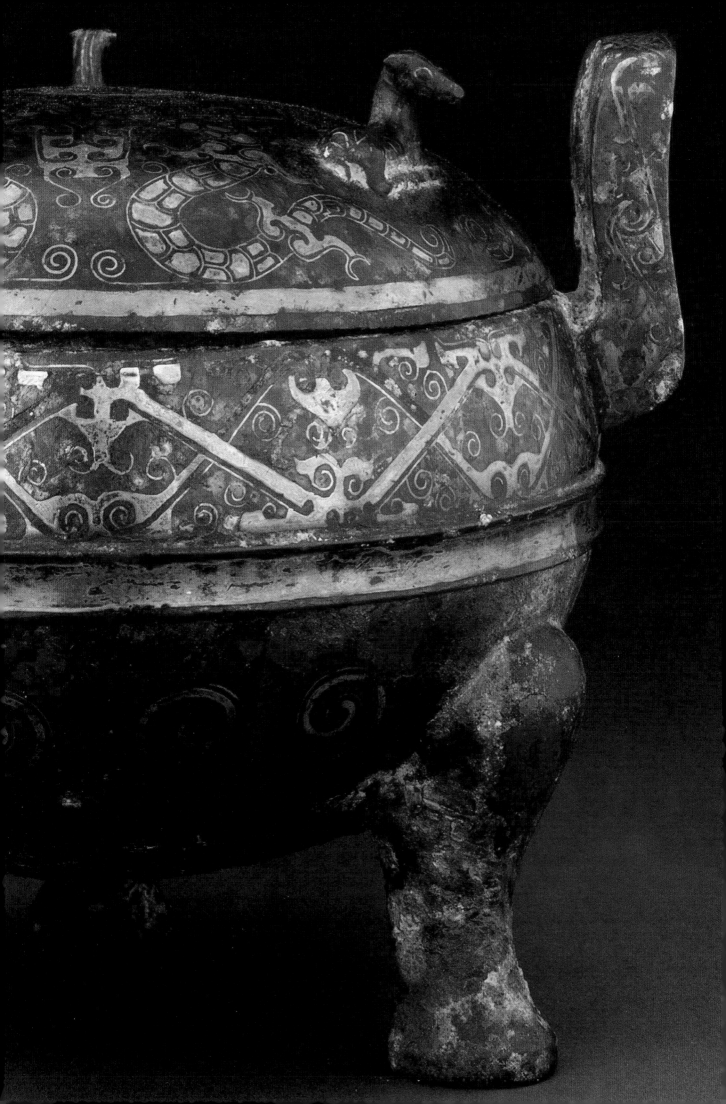

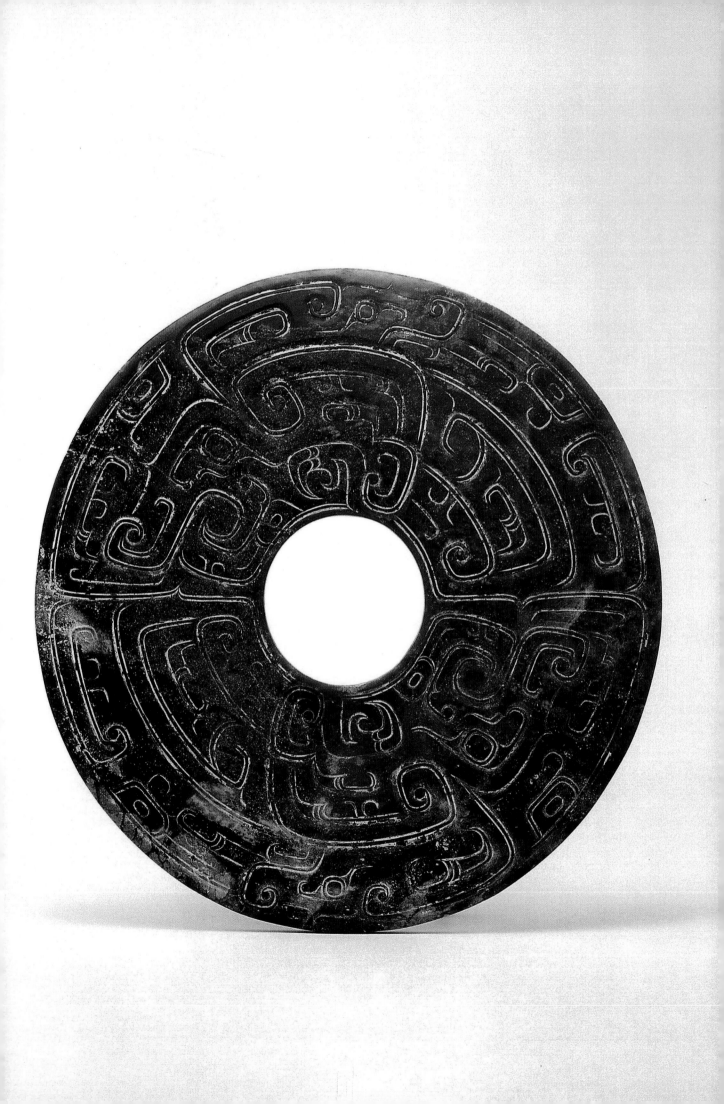

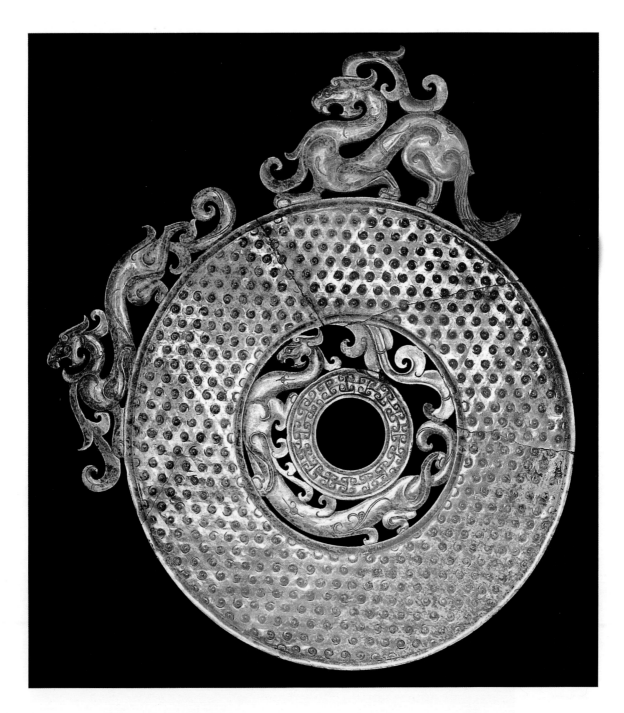

The raised geometric pattern covering the surface of this *bi*
contrasts with the curvilinear, interlacing dragon or feline
figures that appear on the outer edge. The invention of cast
iron during the late Zhou period provided artisans with
the rotary tools needed to create elaborate, pierced designs.

Bi Disk

The abstract, stylized animal forms that appear in con-
centric bands on this *bi* make it dramatically different
from its earlier, undecorated Neolithic and Shang counter-
parts. Although the significance of these ancient jade
carvings is unknown, their frequent presence in burials
suggests that they served some important ritual function.

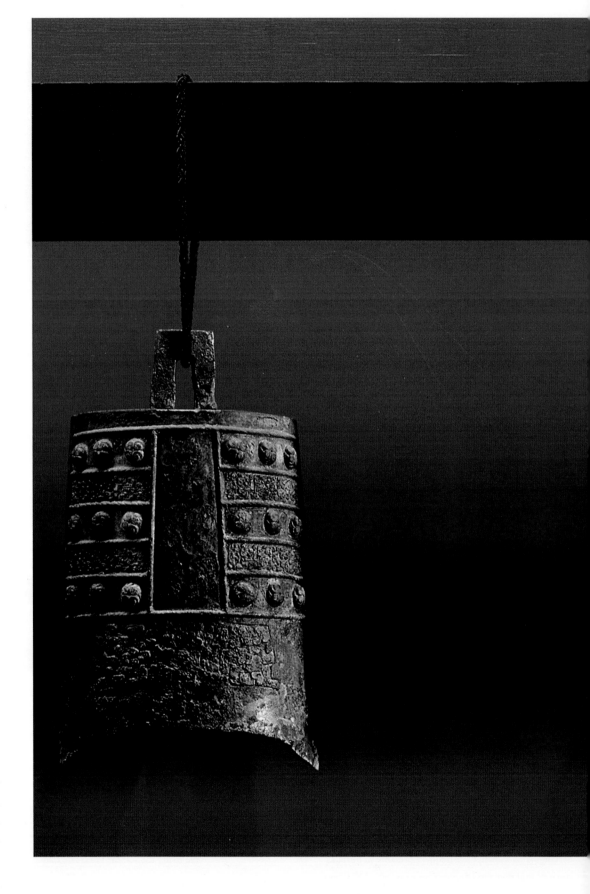

Zhong **Bells**

*From the tomb of the
Marquis of Cai, Shou Xian,
Anhui province, Late Zhou
period, early 5th century B.C.E.;
three of a set of nine bronze
bells. National Museum,
Beijing.*

Musical rituals played an
important role in late
Shang and Zhou culture.
Different tones were
sounded on these clap-
perless, tuned bells by
striking them at the side
or at the center. Sets of
large bells such as these
were made in graduated
sizes and suspended
from wooden frames.

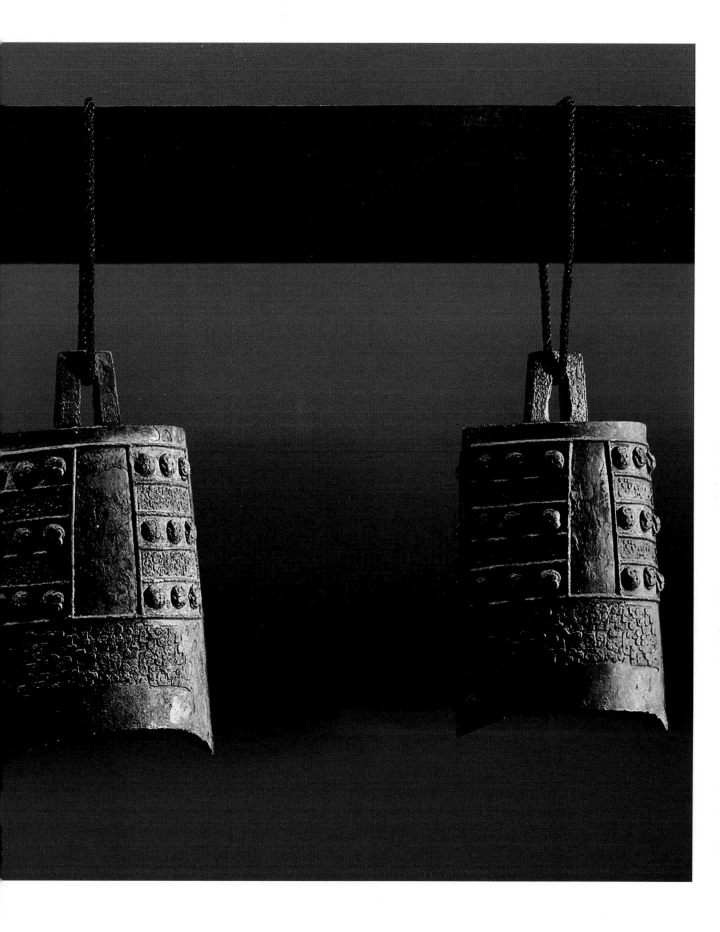

Many new materials and techniques were introduced during the turbulent years of the late Zhou period. Bronze vessels were increasingly put to secular use—much to the dismay of the conservative philosopher Confucius—and came to be valued purely for their aesthetic appeal rather than for their original ritual function. Gold and silver inlays began to appear on the surface of bronze vessels and on the back of the bronze mirrors that served both for everyday use and as burial objects. Applied to the cast bronzes by hand, inlaid decoration typically involved interlocked or intertwined geometric forms and a new hooked spiral motif. The use of colorful metal inlays, as well as the depiction of hunting scenes and lively animal motifs, may have been inspired by the decorative styles favored by nomadic people of the northern steppes.

Many superb jade pieces were produced at this time as well, including such utilitarian objects as hairpins, pendants, and garment hooks. Even ancient ritual objects such as the *bi* and *cong* came to be prized for their ornamental value. Like the bronzes of this period, jade pieces were characterized by interlacing designs, raised dots, and the recurring hooked spiral motif.

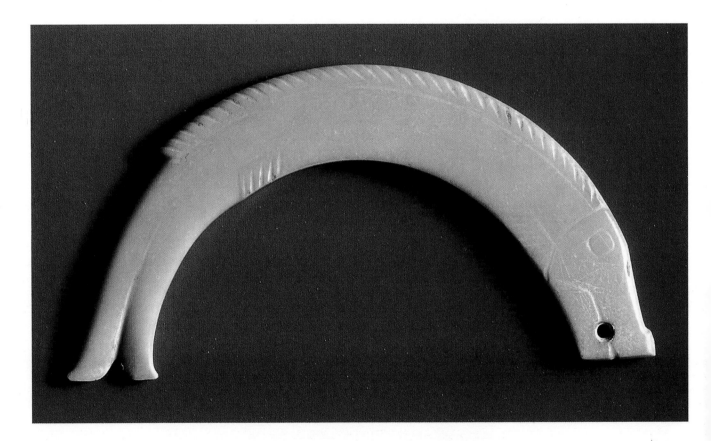

Fish

Early Zhou period; jade; 3½ in. wide (8.8 cm).

Anonymous gift, 1952.577, The Cleveland Museum of Art.

Ancient Chinese believed that jade possessed supernatural powers, and jade ritual objects continued to be made throughout China's history. Most early Zhou jade pendants and amulets were carved from flat slabs of jade with decoration limited to shallow incised lines.

Boy

Late Zhou period; bronze; 4 in. high (10.2 cm). Gift of Ernest Erickson Foundation, Inc., 1985, The Metropolitan Museum of Art, New York.

Human figures in the round were extremely rare before the late Zhou period. This naturalistic figure of a boy dancing is remarkable for creating an illusion of movement in space.

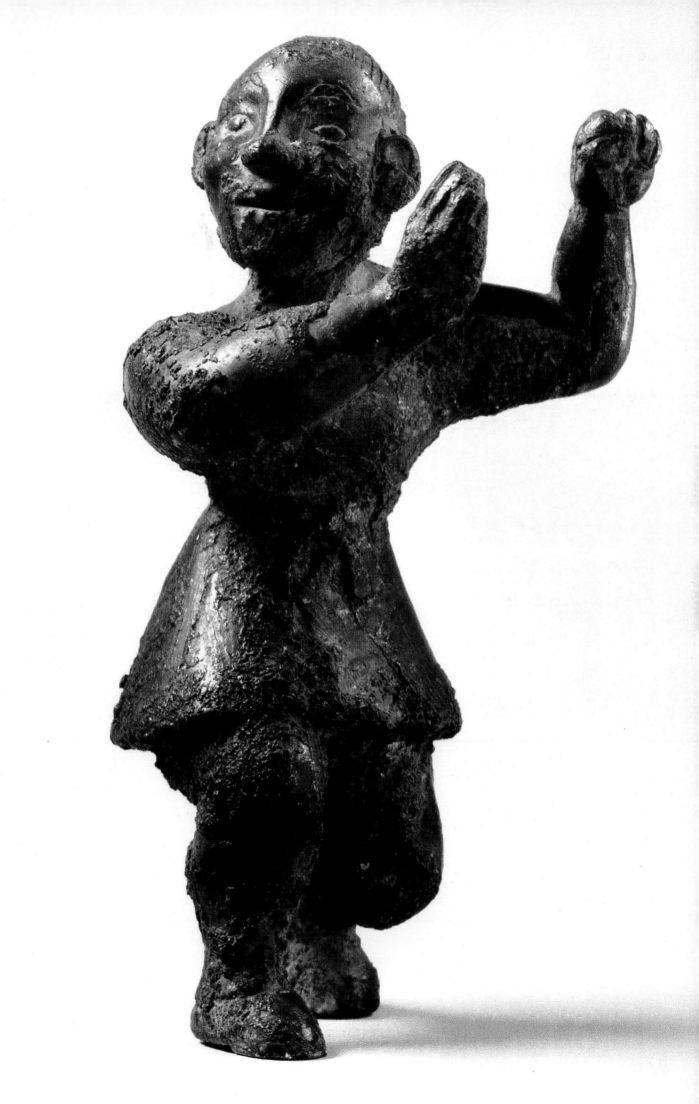

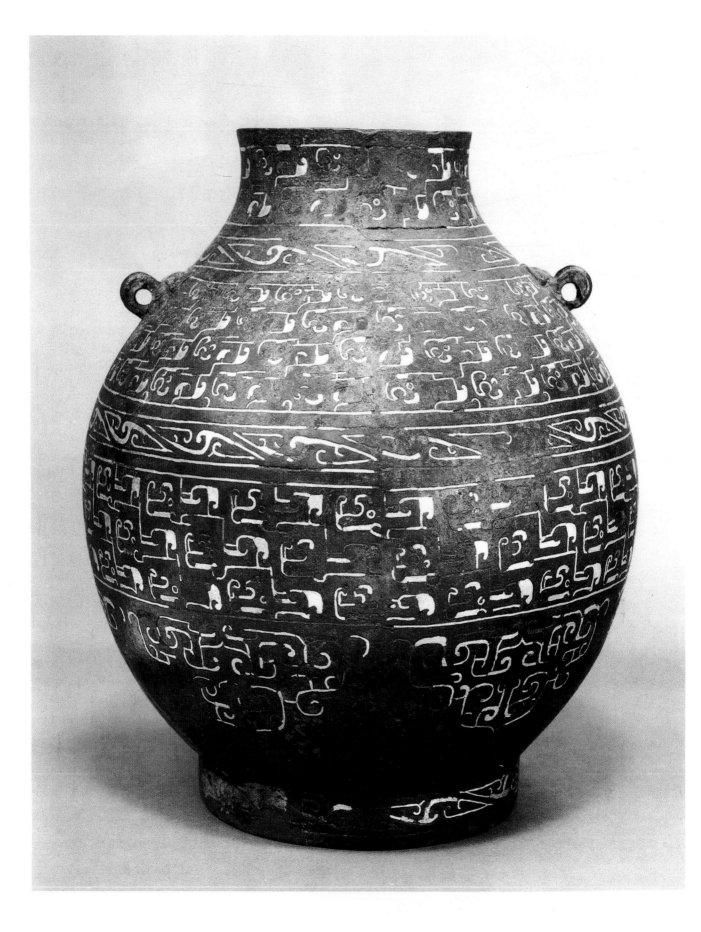

The earliest surviving Chinese objects made of lacquered wood date from the late Zhou period. In the 1930s, workers building a railroad in Changsha in Hunan province uncovered tombs in which such objects as bamboo strips inscribed with an archaic script, fragments of painted silk, and carved and lacquered wooden figures had been remarkably well preserved as a result of the damp earth and superior tomb technology. Lacquer, which is made from the pure sap of the lac tree with color added, was painstakingly applied in thin layers over a core of wood, cloth, or bamboo to make beautiful bowls, boxes, trays, and tables. The lively designs on these elegant, lightweight objects in black and red lacquer are often reminiscent of those seen on the gold and silver inlaid bronzes of the period.

Brush painting, which would ultimately achieve great prominence among Chinese art forms, had its beginnings in the late Zhou period as well. Unfortunately, only a few examples of these paintings have survived. Among them are the fragments of ink paintings on silk found at Changsha, some painted lacquer, and a pair of hunting scenes executed on clam shells.

Bowl

From Changsha, Hunan province, late Zhou period; lacquered wood; 10 in. diameter (25.4 cm). Seattle Art Museum. The expressive, fluid lines of the swirling, abstracted birds, dragons, and banners in this remarkably well-preserved bowl seem to reflect the Daoist conception of a flowing and harmonious universe.

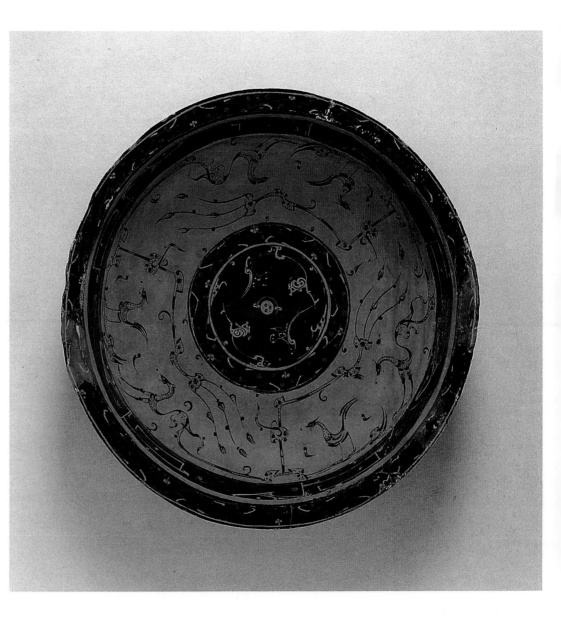

Hu, **Ritual Wine Vessel**

Late Zhou period; inlaid bronze; 10 in. high (25.4 cm). Purchase from the J.H. Wade Fund, 1929.984, The Cleveland Museum of Art. Ritual wine vessels such as this were usually used in pairs from the Middle Zhou period onward.

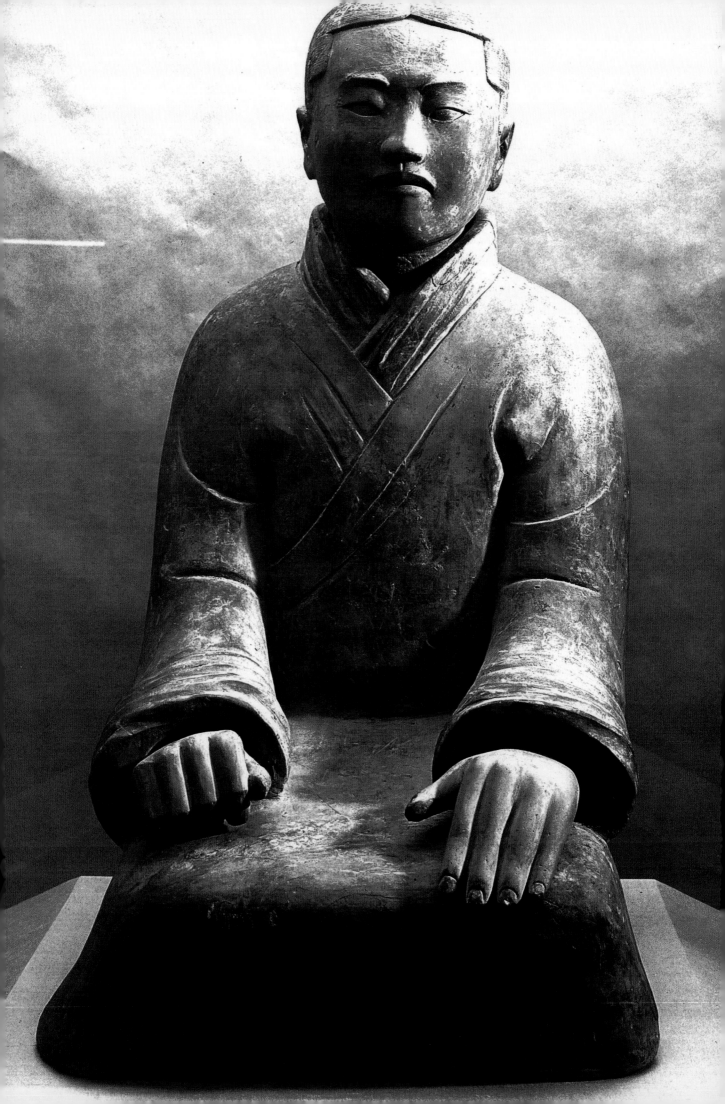

CHAPTER TWO

CONSOLIDATION AND EXPANSION

Many contenders had struggled for control of China during the late Zhou period—also called the period of the Warring States (475–221 B.C.E.)—before the short-lived Qin (pronounced "chin") dynasty emerged victorious. Despite the ongoing political turmoil, however, cities grew larger and trade flourished throughout the war-torn region. Under Qin and Han rule, China would continue to grow and prosper as a unified nation for the next four centuries.

Qin Dynasty (221 - 206 B.C.E.)

After more than two centuries of conflict, the state of Qin (from which the European name "China" was derived) emerged victorious around 221 B.C.E.

The king of the Qin proclaimed himself First Emperor, or *Shi Huang Di*, of China. The First Emperor achieved a great deal during his brief reign. He centralized the Chinese government, standardized Chinese weights, measures, coinage, and written language (in the form of "seal script") throughout the empire, and created the Great Wall by connecting sections of existing walls that had been built over the preceding centuries to keep out invaders from the north. Unfortunately for his subjects, however, the First Emperor was a merciless tyrant who slaughtered political enemies, conscripted hundreds of thousands of laborers to work on his palace and other projects, banned books, and ruthlessly persecuted anyone who

The Great Wall of China

Photograph by Erich Lessing

The largest manmade structure in the world, the Great Wall stretches 1,500 miles (2,413 kilometers) along China's northern frontier. Built of earth, stone, and brick, much of the wall was completed under the rule of the First Emperor (c. 221–210 B.C.E.) to keep out nomadic invaders from the north.

Tomb Figure of a Kneeling Woman

Lintong, Shaanxi province, Qin dynasty; earthenware 25⅛ in. (64.5 cm). National Museum, Beijing.

Although the unfired colored pigments used to decorate tomb figures were not permanent, remaining traces of paint suggest that these figures were once brightly painted. The sensitive, individualized rendering of these small sculptures reflects the extraordinary quality of early Chinese figural art.

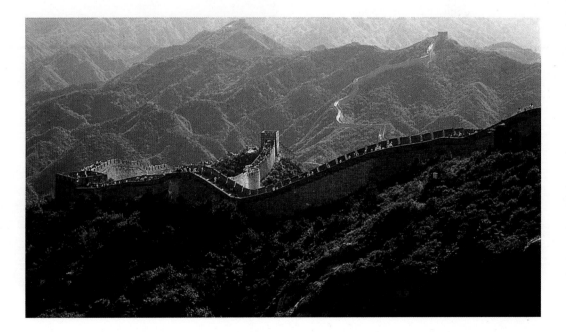

35

dared promote the teachings of Confucius. Within four years of the First Emperor's death, the totalitarian rule of the Qin dynasty would be overthrown by rebel forces.

Prior to the late Zhou period, it was customary for people, animals, and useful objects of all kinds to be buried along with kings and wealthy nobles to assure that their needs would be well served in the afterlife. Outlying chambers of royal Shang and Zhou tombs were often found to contain the remains of servants, soldiers, musicians, and horses that had been sacrificed to accompany the king after his death. By the late Zhou period, wood, stone, or pottery replicas of furniture, servants, and domestic animals had begun to be entombed as symbolic replacements for the people and objects they represented.

When well-diggers working near Xi'an accidentally unearthed the burial site of the first Qin emperor in 1974, the vast tomb complex was discovered to contain—in addition to various jade and bronze treasures—more than eight thousand life-sized clay figures of warriors and horses lined up in military formation as if to protect the tomb. Convincingly lifelike, realistically positioned, and equipped with real weapons, armor, and wooden chariots, the members of this extraordinary clay army served as burial substitutes on a grand scale.

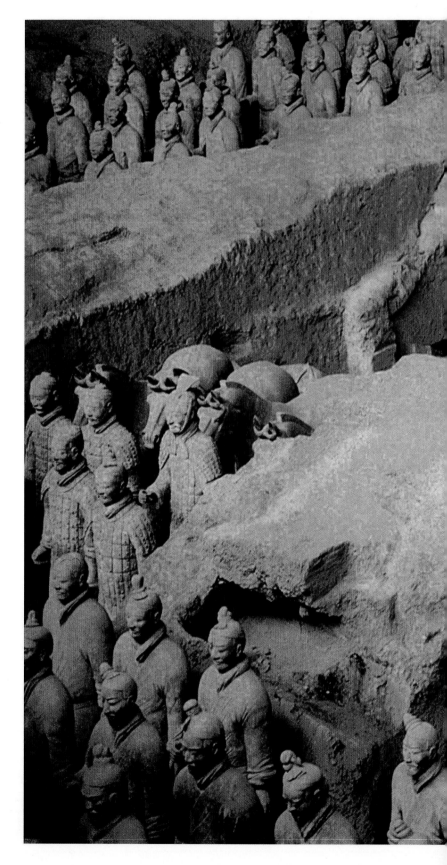

**Tomb Pit with Part of Burial Army
of the First Emperor of the Qin dynasty**

*From Lintong, Shaanxi province, Qin dynasty,
c. 210 B.C.E.; terracotta. Photograph by Erich Lessing.*
More than eight thousand life-size clay replicas
of infantrymen, cavalry, archers, and charioteers
were entombed along with the First Emperor
of the Qin dynasty. These once brightly painted
figures of fired gray clay were carefully finished by
hand to allow for individualized facial features.

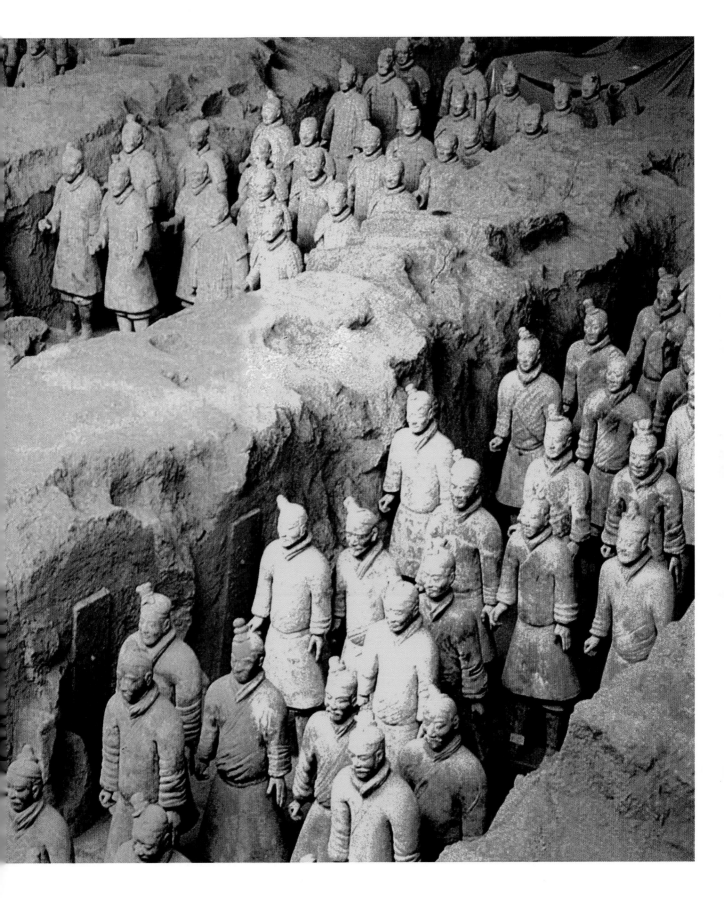

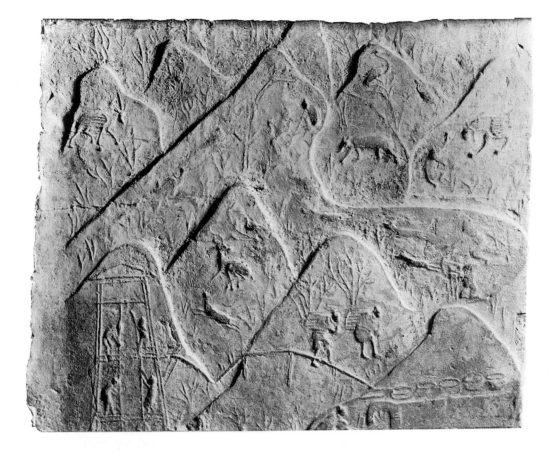

Salt-Mining Scene

*From Yangzishan,
Sichuan province, Han
dynasty, second century;
impressed earthenware tile.
Werner Forman Archive/
Art Resource, New York.*
This decorated tomb
tile depicts salt miners
at work and hunters
shooting at game.
The derrick seen in
the lower left was
used to drill for salt,
which was subse-
quently dissolved in
water and dried in pans.

**Tomb Model
of a House**

*Han dynasty; painted earth-
enware; 52 x 33½ x 27 in.
(132.1 x 85.1 x 68.6 cm).
Purchase: Nelson Trust,
The Nelson-Atkins Museum,
Kansas City, Missouri.*
Painted in unfired
pigments over white slip,
this funerary model
shows the type of wall
paintings that were pre-
sumably painted on im-
perial palaces during the
Han period. The elabo-
rate painting on this
model includes birds
perched in the stylized
trees flanking the double
door on the ground floor.

Han Dynasty (206 B.C.E. - 220 C.E.)

Lasting more than four hundred years, the glorious Han dynasty was roughly contemporaneous with the Roman Empire that dominated the Western world at the same time. Uniting the northern and southern regions of China's vast territory, the Han rulers established many of the distinctly Chinese cultural patterns that have survived into the twenti-eth century. To this day, native Chinese people refer to themselves as *Hanzu ren,* or "people of Han."

In contrast to the despotic Qin, the Han emper-ors proved to be benevolent and tolerant rulers of their far-flung empire. As trade proliferated by sea and along the overland Silk Route through Central Asia, China was exposed to cultural influences from places as diverse as India, Japan, Southeast Asia, and the Roman Empire. A rebirth of learning took place under Han rule as a royal command to search for lost classics led to a renewed interest in Confucian texts and other historical works that had been repressed by the Qin. A civil service exami-nation system was instituted to select officials educated in the Confucian classics, and both Con-fucian and Daoist ideas influenced the shaping of Han culture. Detailed histories were written to record China's history back to its mythical origins, and the meticulous format established by Han historians continued to be followed by Chinese historians until the end of the imperial period in the early twentieth century. With the invention of paper around the end of the first century C.E., records previously kept on silk or on strips of wood or bamboo began to be kept on paper as well.

One of the very few Han paintings to have sur-vived to the present day is a painted, T-shaped silk banner dating back to the year 180. The oldest known form of a Chinese hanging scroll, the ban-ner was found draping the innermost of three nested wooden coffins in the tomb of the Marquise of Dai. The body of the marquise was astonish-ingly well preserved, allowing for a positive identi-fication with one of the women portrayed on the banner. Undisturbed until its excavation in 1971, the tomb, which was found near Changsha, also contained several well-preserved examples of early Han lacquered utensils and embroidered textiles.

Several styles of painting emerged during the Han period. Some paintings, such as the famous

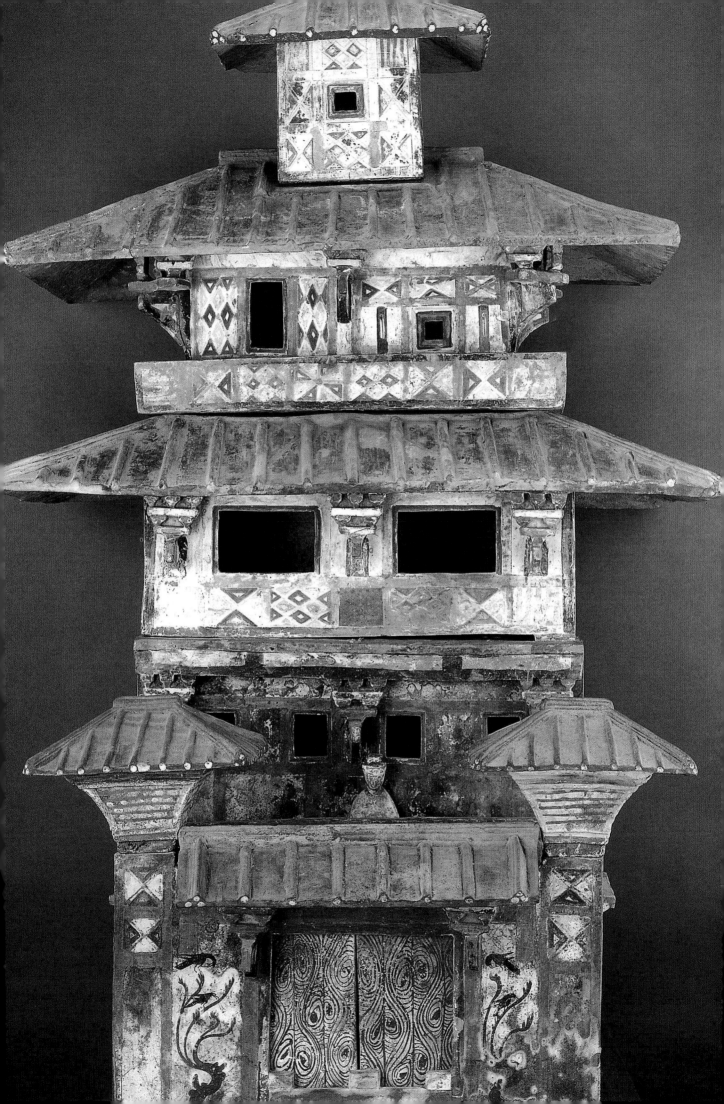

Scenes of Paragons of Filial Piety that was painted on a lacquered wicker basket, followed the formal tradition reflected in relief carvings of the period by depicting static, evenly spaced figures with little sense of motion. A different style is seen in a painted earthenware tile from the gable of a tomb shrine. The mostly silhouetted forms of the *Gentlemen in Conversation* were painted with sweeping, calligraphic lines of varying thickness that appear to have been rapidly executed. Confucian influence is felt in the emphasis on a humanistic, secular subject matter, the clarity of the non-overlapping figures, and the underlying sense of restraint and orderliness. The Han interest in naturalism is reflected in the lively, naturalistic depictions of human and animal forms depicted in earthenware tomb tiles.

Gentlemen in Conversation

Han dynasty, 1st century; painted earthenware tile lintel; 7½ in. high x 7 ft. 10⅝ in. wide (19 x 240 cm). Museum of Fine Arts, Boston. The artist responsible for this early example of brush painting used rapidly executed brushstrokes of varying thicknesses to convey the distinctive character of each figure in this lively narrative scene.

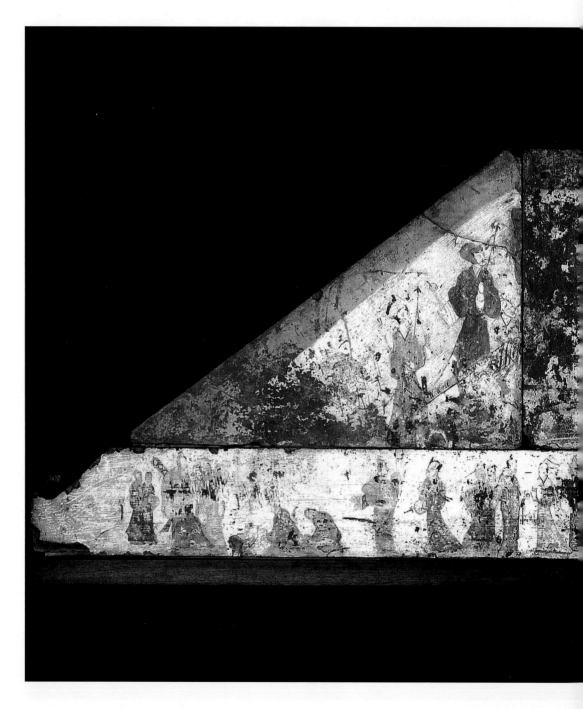

Sculpture in stone during the Han dynasty was limited almost exclusively to funerary monuments and tomb decoration. Han tombs were often furnished with beautiful objects that were intended for use in the afterlife. Burial substitutes from the Han period include small earthenware tomb figures of horses, dogs, and people. Elaborate burial substitutes of houses, granaries, towers, and other buildings reveal a great deal about Han architectural forms, although no actual buildings from this period have survived. These tomb models, made of gray clay covered with a white slip and then glazed or painted red or green, illustrate a type of architecture used throughout Chinese history. The use of tomb models declined sharply at the end of the Han period but recurred several centuries later.

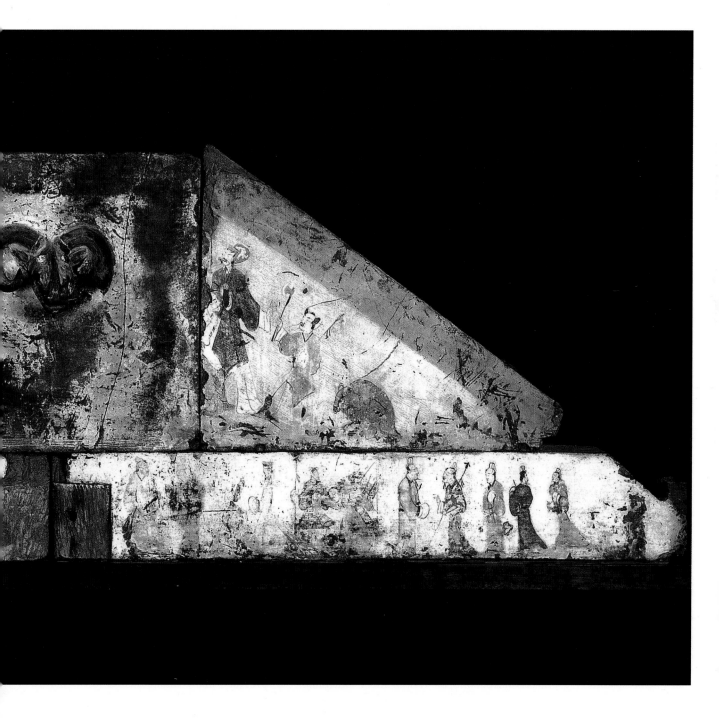

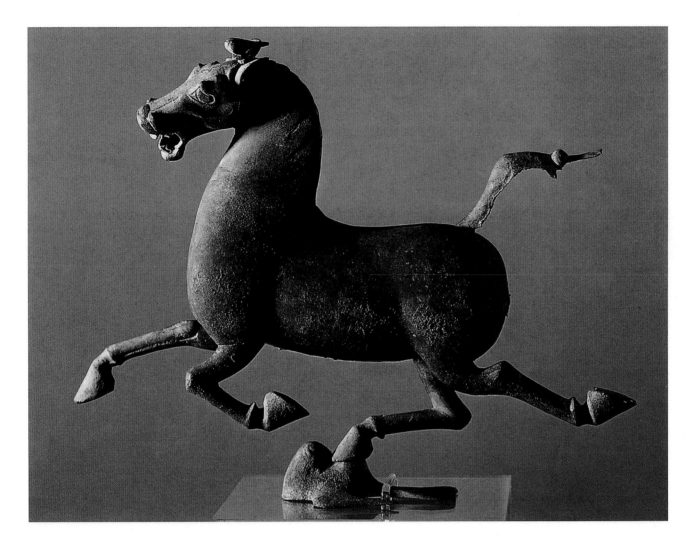

Flying Horse

From Wuwei, Gansu province,
Han dynasty, 2nd century;
bronze; 13½ in. high (34.2 cm).
Historical Museum, Beijing.
The horse was a favorite
subject of Chinese art
since ancient times.
This outstanding sculp-
ture was one of thirty-
nine bronze horses
found in the richly-
appointed tomb of an
important Han official.
The right rear hoof of
the galloping horse rests
lightly on a swallow
with wings outstretched
to symbolize speed.

Bronze continued to be used both for ritual and utilitarian objects during the Han dynasty. Excavated Han tombs were found to contain brass swords, carriage fittings, belt buckles, and assorted household utensils, sometimes richly decorated with inlays of gold, silver, turquoise, or jade, as well as bronze mirrors decorated with ornate cosmic symbolism. Perhaps the best-known and most sculpturally sophisticated of all Chinese tomb figurines is the lively bronze *Flying Horse* found in Gansu province in a tomb dating from the late Han period.

The richly appointed rock-cut tombs of Prince Liu Sheng (whose death is dated to 113 B.C.E.) and Princess Dou Wan were discovered in the side of a mountain about 90 miles (145 kilometers) south-west of Beijing. Among almost three thousand objects surrounding the rear chamber containing the remains of the prince and princess were stone figures of servants, magnificent gold and bronze vessels, mirrors, jade pendants, incense burners, and bronze lamps. For the most part, these were not specially made as burial substitutes but, rather, were treasures of immense value that had belonged to the royal couple. Also found in the tombs were the intricate jade suits, sewed with gold thread, in which the royal couple were buried. Both jade and gold were believed to have preservative powers.

Han ceramic vessels were made for both household use and as burial pottery. *Yue* ware, a high-fired iron-glazed stoneware that was first produced in southern China in the second cen-tury, was the first of the classic Chinese wares and the ancestor of the celadon tradition. Funerary wares in the form of miniaturized replicas of people, buildings, and household effects have provided many valuable clues to the nature of everyday life in Han China.

**Incense Burner
Supported by Figure
Atop a Beast**

*From the tomb of Princess
Dou Wan, Mancheng, Hebei
province, Han dynasty, late 2nd
century B.C.E.; bronze; 12⅝ in.
high (32.4 cm). Giraudon/
Art Resource, New York.*

This mountain-shaped
incense burner has a
pierced, conical lid that
allows the escaping smoke
to rise up like the breath
of the mountain. Small
human and animal figures
roam among the high peaks,
which represent the moun-
tainous Isle of the Immortals
described in Daoist myth.

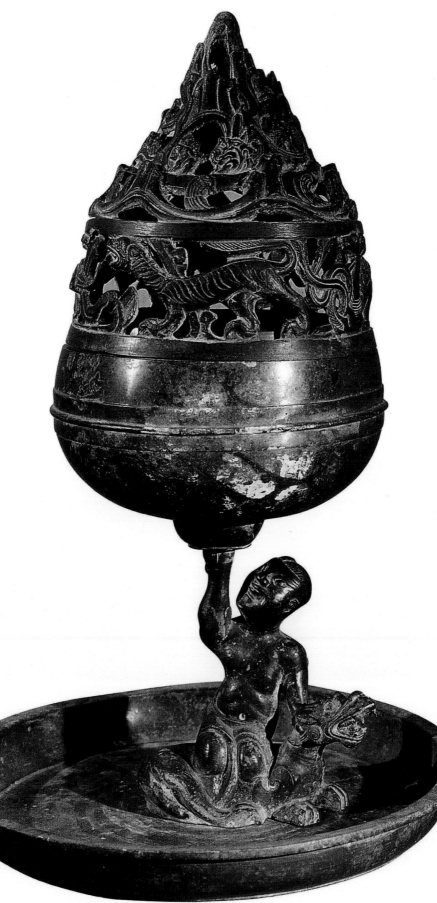

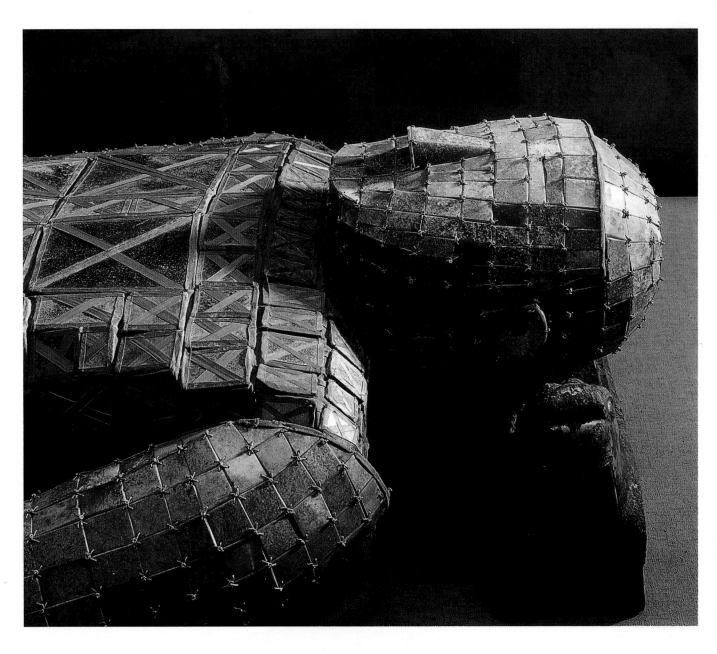

Detail of Burial Suit

detail; from the tomb of Princess Dou Wan,

Mancheng, Hebei province, Han dynasty, late 2nd century B.C.E.;

jade sewn with gold thread. National Museum, Beijing.

Jade shrouds were sewn with gold, silver, or copper thread, depending on the rank of the deceased. The 2,160 pieces of jade of Princess Dou Wan's burial suit were sewn with gold thread through holes made at the four corners.

Burial Suit

From the tomb of Princess Dou Wan, Mancheng, Hebei province,

Han dynasty, late 2nd century B.C.E.; jade sewn with gold

thread; 67 in. long (172 cm). National Museum, Beijing.

Long associated with immortality, jade was believed to have the power to preserve entombed bodies. The burial suit in Princess Dou Wan's tomb was found in a collapsed state and reassembled to its original form.

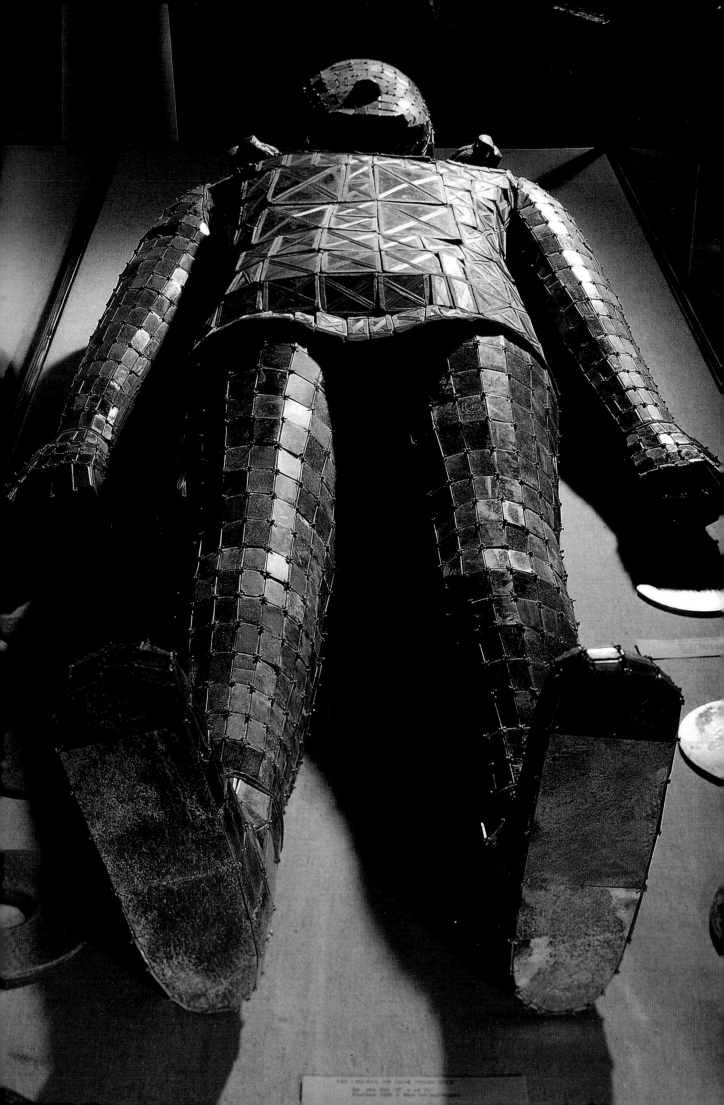

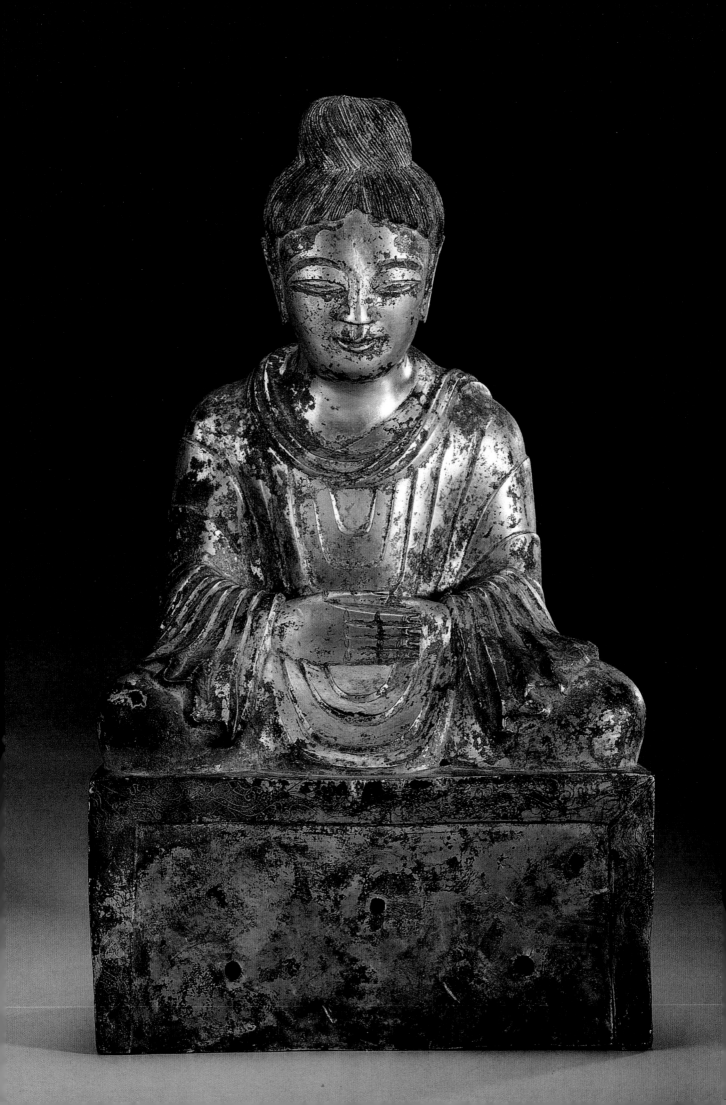

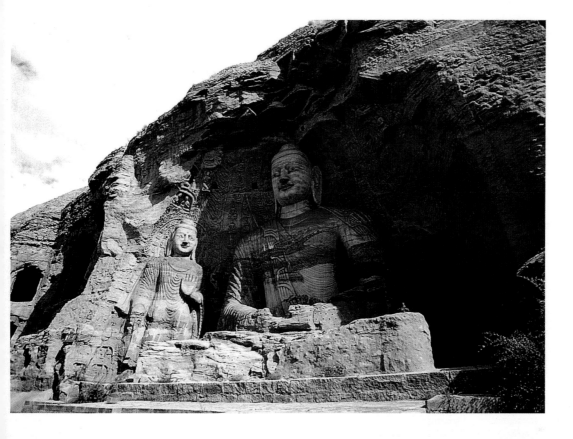

Colossal Buddha

From Cave 20, Yungang,
Shanxi province, Six
Dynasties period, late fifth
century; stone; 45 ft. high
(13.7 m). Photograph by
Dennis Cox, ChinaStock.
This immense, broad-shouldered Buddha sits cross-legged in a meditative pose. With its bulkier, geometrically simplified form and raised band drapery, the figure has a distinctively Chinese quality that sets it apart from the Indian prototypes upon which it was based.

Period of Disunion and Sui Dynasty (220 – 618)

With the collapse of the Han empire in the third century, China entered a long period of national disunity. The Chinese court fled south to Jiankang (present-day Nanjing), leaving northern China to be ruled by a succession of invaders from Central Asia. The most influential of these foreign rulers were the Northern Wei, who succeeded in unifying all of northern China from 386 to 535. Buddhism, which had been introduced into China from India during the Han dynasty, was embraced by the Northern Wei rulers and gradually spread throughout the country. Despite their diminishing influence, both Confucianism and Daoism survived the advent of Buddhism in China.

The period of disunion witnessed the gradual evolution of a distinctly Chinese style of Buddhist art. The few surviving Chinese Buddhist sculptures that predate the Northern Wei dynasty distinctly echo the Gandhara style imported from India, which, in turn, was heavily influenced by

Greco-Roman sculptural traditions. The earliest Chinese Buddhist sculpture to which a date can be ascribed, a small gilt bronze seated Buddha dated 338, lacks the sensual modeling that characterizes Gandharan images; rather, the facial features, the emphasis on the head and hands, and the symmetrical, rectilinear folds of the garment impart to the figure a distinctly Chinese flavor.

Buddhist monasteries and temples thrived under imperial patronage, and the religion was eventually embraced by most of northern China. During the second half of the fifth century, a complex of cave temples were cut into the face of a cliff at Yungang near the Northern Wei capital at Datong in Shanxi province. Among the many relief sculptures carved into the living rock were several massive, seated Buddhas executed in a style that is closely related to that of the earlier Colossal Buddha of Bamiyan in present-day Afghanistan. The large scale of these monumental sculptures was unprecedented in Chinese art. The largest Chinese gilt bronze sculpture surviv-

Seated Buddha

Six Dynasties period,
dated 338; gilt bronze;
15½ in. high (39.3 cm). Asian
Art Museum, San Francisco.
The style of this small gilt bronze, which is the earliest surviving dated Chinese image of the Buddha, is derived from Indian prototypes. Although many votive bronze images were produced, many were melted down during the widespread persecution of Buddhism that took place in the mid-ninth century.

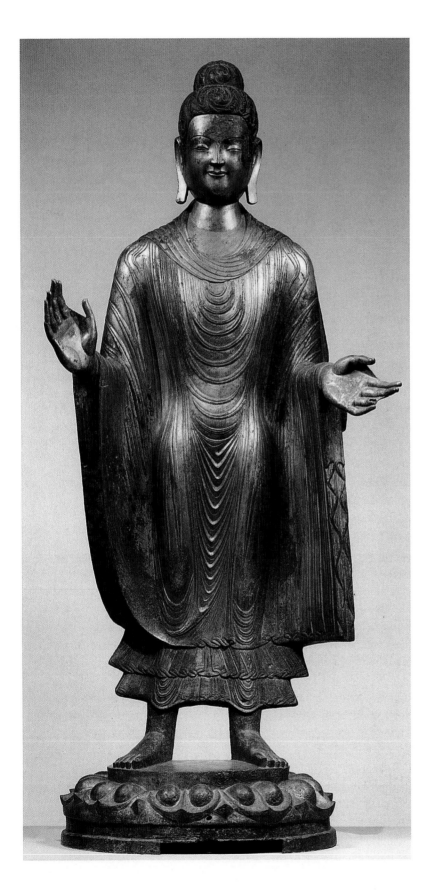

ing from the Northern Wei period that is similar in style to the Colossal Buddha at Yungang is a Standing Buddha dated to 477. Although the body of the Buddha, which stands nearly 5 feet tall, is clearly observable beneath the figure's clinging garment—a stylistic convention associated with Indian and Central Asian sculpture—the stylized folds of the drapery reflect the traditional Chinese preference for linearity over three-dimensional representation. Relief sculptures at the slightly later Buddhist cave complex in Longmen were executed in such low relief and with such great linear detail that the figures appear almost to be painted onto the rock.

During the period of disunion, southern China was ruled by six short-lived dynasties, all of which kept their capital at the political and cultural center of Jiankang. Despite the persistent influence of Confucianism and Daoism, Buddhism continued to spread throughout southern China during the Six Dynasties period (265–589). Many small gilt bronze Buddhist sculptures were made at this time as temple offerings or for use in private family shrines.

Standing Buddha

N. Wei dynasty, fifth century; gilt bronze; 55¼ x 19½ in.
(104.3 x 48.9 cm). John Stewart Kennedy Fund,
1926, The Metropolitan Museum of Art, New York.
The Buddha's cranial protuberance, which
symbolizes his wisdom, and his elongated ear-
lobes, which refer to the heavy earrings that the
Buddha wore as a prince prior to his enlightenment,
are iconographic features established in India.
The clinging robe reflects the sensuous style
of Indian and Central Asian Buddhist sculptures.

Seated Bodhisattva

Longmen, Henan province,
Northern Wei dynasty, c. 520;
limestone; 16 in. high (41 cm).
Musée Guimet, Paris.

This blackish-gray limestone
sculpture of Guanyin is
typical of the sixth-century
Chinese figure style. The
fluid, calligraphic rhythm of
the robe and the slenderness
of the figure are quite
distinct from the earlier
Indian-influenced toga-clad
Buddhas at Yungang.

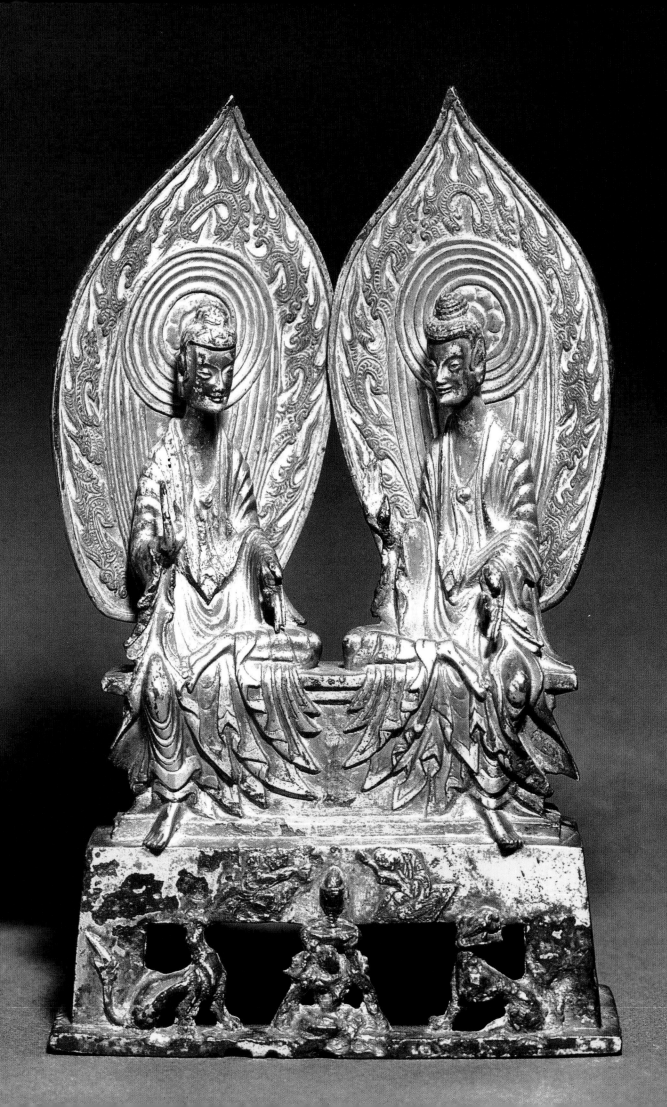

A new wave of Indian influence late in the Six Dynasties period led to a revival of Chinese interest in Indian sculptural traditions. The earlier emphasis on two-dimensional linearity was largely abandoned in favor of more full-bodied, columnar forms. Monumental sculptures in this style highlighted the contrast between the figures' elaborate jewelry and the smooth surface of their cylindrical bodies. The subsequent development of a fully realized Chinese style, which was based on the earlier columnar style but with the body obscured by drapery, is illustrated by a gilt bronze portable altarpiece dated to the Sui dynasty (589–618), which finally reunited China after three centuries of division. This elegant, symmetrical altarpiece depicts Amitabha, the Buddha of the West, seated in the Western Paradise, flanked by attendants and two bodhisattvas—individuals who have attained enlightenment but decline Buddhahood in order to help other seekers.

Painted murals, clay sculptures, and stucco sculptures in the round dating from the fifth to the thirteenth century were discovered in approximately five hundred caves at the eastern terminus of the Silk Route at Dunhuang in northwestern China. The wall paintings in the earliest caves show a mixture of Indian, Central Asian, and Chinese painting styles. Executed in broad bands of

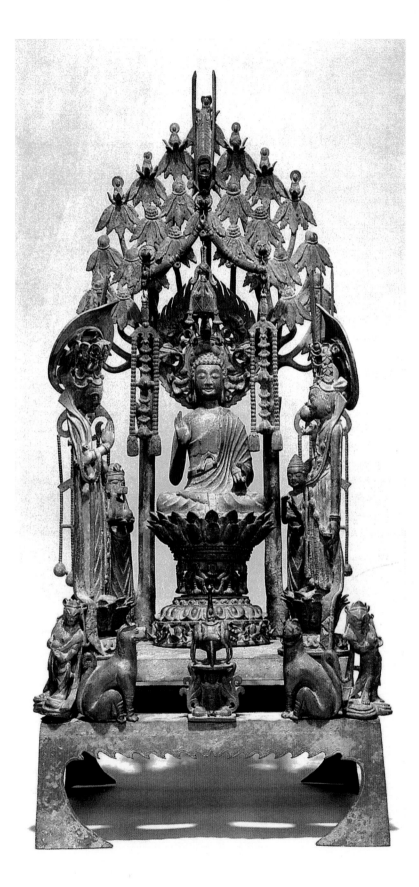

Amitabha Altar

Dated 593, Sui dynasty; bronze;
30⅛ in. high (76.5 cm). Museum of Fine Arts, Boston.
The Buddha of Boundless Splendor sits on a lotus throne beneath the jeweled trees of the Western Paradise attended by disciples and bodhisattvas. A pair of lions and a pair of guardians flank the incense burner at his feet.

Shakyamuni and Prabhutaratna

Dated 518, Six Dynasties period; gilt bronze;
10¼ in. high (36. cm). Musée Guimet, Paris.
Prabhutaratna (the Buddha of the Remote Past) comes to bear witness to the teachings of Shakyamuni (the historical Buddha), symbolizing the continuity of Buddhist law throughout time. Seated before a flame body halo, or *mandorla*, these wispy, ethereal figures with their sloping shoulders and linear, waterfall drapery reminiscent of brushwork are distinctly Chinese in appearance.

Guardian Lion

Six Dynasties period; gray stone. Art Resource, New York. Pairs of animal figures such as this fierce lion flanked the "spirit paths" leading to the tombs of emperors and high-ranking nobles. They served as honor guards for the funeral procession and as protectors of the tombs.

Dynasties period demonstrate the remarkable technical advances that had been achieved by Chinese artisans. *Yue* wares were produced in a great variety of shapes and forms. These green-glazed vessels were traded extensively with merchants in the Near East, beginning China's long history of exporting ceramics. Toward the end of the period, craftsmen in the north showed an interest in the production of white stoneware for the first time since the Shang dynasty. Distinguished by their simple, robust, and highly sculptural shapes, these beautiful white wares were the precursors of the fine white porcelain of the Tang and Song dynasties.

The earliest known great masters of Chinese painting and the earliest known writings on painting theory both date from the Six Dynasties period. In his treatise *Six Canons of Painting*, the sixth-century art theorist Xie He (c. 500–c. 535) established the criteria by which all subsequent Chinese painting would be judged. According to Xie He, the first and most important principle of painting is "animation through spirit resonance." By this, Xie He meant that the painter must strive to imbue his work with vital energy, or *qi yun*. The second principle, which concerns the proper use of the brush, was considered almost as important as capturing spirit resonance. In China, where calligraphy has traditionally been regarded as a higher form of art than painting, artists are judged by the quality of their brushstrokes. In addition to spirit resonance and brushwork, the criteria by which Xie He evaluated painting were the naturalistic depiction of forms, the proper use of color, efficacy of composition, and skill in copying earlier masters. In China, copying has traditionally been viewed not as mere imitation but as an important way of learning from and absorbing the creative genius of past masters.

Although little remains of painting from this period, a few faithful copies in the style of the Six Dynasties masters have survived. The earliest known, and perhaps finest, of these is the

flat color with attempts at shading, some of these paintings illustrate tales of the Buddha's previous incarnations. By the time of the Sui dynasty, illustrations of these tales, called *jatakas*, would be largely supplanted by representations of the Buddhas of the past and of Maitreya, the Buddha of the Future.

Non-Buddhist sculptures of the Six Dynasties period show little stylistic development since the Zhou and Han periods. Among the favorite subjects for stone sculptors at this time were animal figures, including the chimera, a fantastic winged creature, part lion and part dragon, that served both to guard the tombs and to transport departed souls to the afterlife. Ceramic tomb figurines of this period, which included horses, dogs, lions, and camels, as well as chimeras, were made of gray earthenware that was sometimes painted red, green, or yellow.

Ceramics made for daily use during the Six

CONSOLIDATION AND EXPANSION

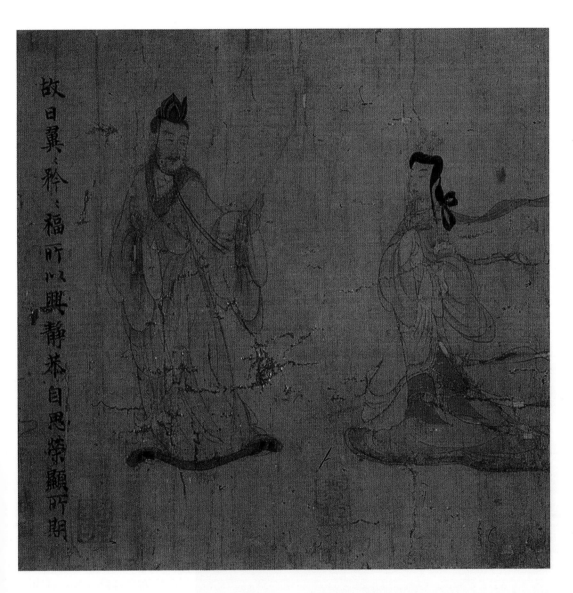

故
日
翼
翼
矜
矜
福
所
以
興
靜
恭
基
自
思
榮
顯
所
期

The Admonitions of the Court Instructress

Attributed to Gu Kaizhi, Six Dynasties period; detail of handscroll: ink and color on silk. British Museum, London. Painted in fine black sinuous lines and flat washes of color on silk, the wispy figures depicted in this scene appear to interact with each other in the absence of any specific background and with minimal props to suggest a setting.

Admonitions of the Court Instructress handscroll, attributed to the famous landscape, portrait, and figure painter Gu Kaizhi (c. 344–c. 406). Illustrating a third-century Confucian poem that describes the behavior considered appropriate for ladies of the court, the handscroll consists of nine paintings and alternating sections of text. Like earlier Confucian-influenced works, this painting places great emphasis on clarity of line with little overlapping of forms. The seventh scene depicts the emperor rejecting an approaching court lady whose swirling draperies—a convention called the "flying scarf" motif—lend the scene a sense of movement and vitality reminiscent of the Han dynasty style used in the wall paintings at Dunhuang. The artist's skill at rendering character is evident in the figures' expressive, individualized faces. The ninth-century art critic Zhang Yanyuan praised Gu Kaizhi, who was known as the father of figure painting, by observing that he captured not only the appearance but the essential life spirit—*qi yun*—of his subjects.

53

Tang Tai Zong's Horse, Saluzi

Designed by Yan Liben, from Emperor's tomb, Liquan Xian, Shaanxi province, dated 636 to 649, Tang dynasty; stone; 68 in. high (172.7 cm).

University Museum, University of Pennsylvania, Philadelphia. This bas-relief stone sculpture of a soldier removing an arrow from a horse's chest is one of six life-sized sculptures depicting Tang Tai Zong's favorite horses. The swift and powerful horses of Central Asia were a popular subject for Tang dynasty court painters.

Tang Dynasty (618 – 907)

After the fall of the short-lived Sui dynasty in 618, the Tang emperor promptly restored order under a centralized Chinese government. The Tang, who considered themselves the rightful heirs to the Han dynasty, encouraged trade and religious pilgrimage across the Asian continent along the overland Silk Route and to Southeast Asia and India by sea. By the early eighth century, the empire stretched across parts of Mongolia, Manchuria, and Central Asia, extending from the China Sea to the Caspian Sea and from Korea in the north to Annan (present-day Vietnam) in the south. Over a million people from all parts of Asia lived within the walls of Chang'an (present-day Xi'an in Shaanxi province), the capital city of the rich and powerful Tang Empire. Here, in the most cosmopolitan city of its time, native Chinese lived and worked among people from Arabia, Turkey, India,

Mongolia, and Japan. For almost 250 years, Tang rule was characterized by a spirit of religious tolerance in which Buddhists, Hindus, Muslims, Jews, Christians, Zoroastrians, and Manichaeans were able to coexist in peaceful harmony. Under enlightened Tang rule, China was a rich environment for the development of literature and the arts.

Both figure and landscape painting thrived under Tang rule. Yan Liben, the leading figure painter of the seventh century, was both an important court artist and a high-ranking government administrator. Yan excelled at creating realistic, individualized portraits in both his paintings and his sculptures. Commissioned to design a series of life-sized stone reliefs of the Emperor Tai Zong's favorite horses to flank the approach to the Emperor's tomb, Yan demonstrated his remarkable capacity for depicting realistic detail on a monumental scale. Yan Liben's finest surviving painting, a handscroll entitled *Portraits of Thirteen Emperors,* displays the exquisite brushwork, strong composition, and masterful use of color that justify the exalted rank Yan Liben holds among Chinese painters.

Chinese historians regard the late eighth century as the golden age of figure painting, and Wu Daozi is generally accepted as being the greatest figure painter of all. Although none of his work has survived, Wu Daozi is renowned for his calligraphic brushwork—that is, the use of lines of varying thickness to express the power of the brush. Wu Daozi served as a painter in the court of Emperor Ming Huang, under whose patronage the arts flourished.

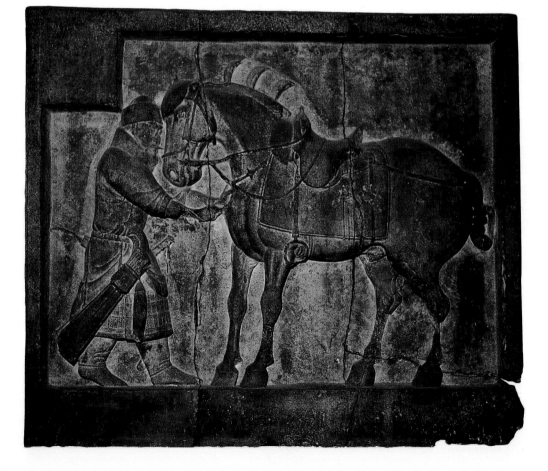

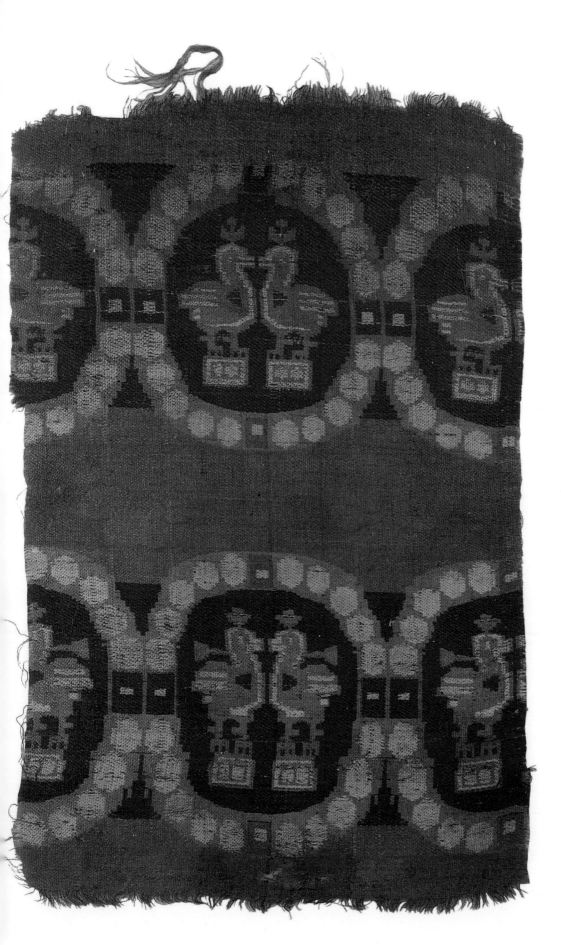

FOLLOWING PAGE:

Emperor Ming Huang's Journey to Shu

Tang dynasty; detail of a hanging scroll: ink and colors on silk; 21¾ x 31 in. (55.2 x 78.7 cm). National Palace Museum, Taibei.
Painted with heavy, yet refined, washes of mineral pigments in cobalt-blue and copper-green with touches of gold, this narrative hanging scroll exemplifies the conservative "blue and green" style associated with the Tang court.

Textile Fragment with Bird Motif

From a tomb at Astana (near Turfan), Xianjiang province, Tang dynasty, seventh century; warp twill woven with silk threads; 10⅛ in. long (26 cm). Giraudon/Art Resource, New York.
Textiles were exported from Tang China to the West in great numbers along the established trade roads known collectively as the Silk Route. Popular decorative motifs for textiles included animals, hunting scenes, and court ladies playing musical instruments.

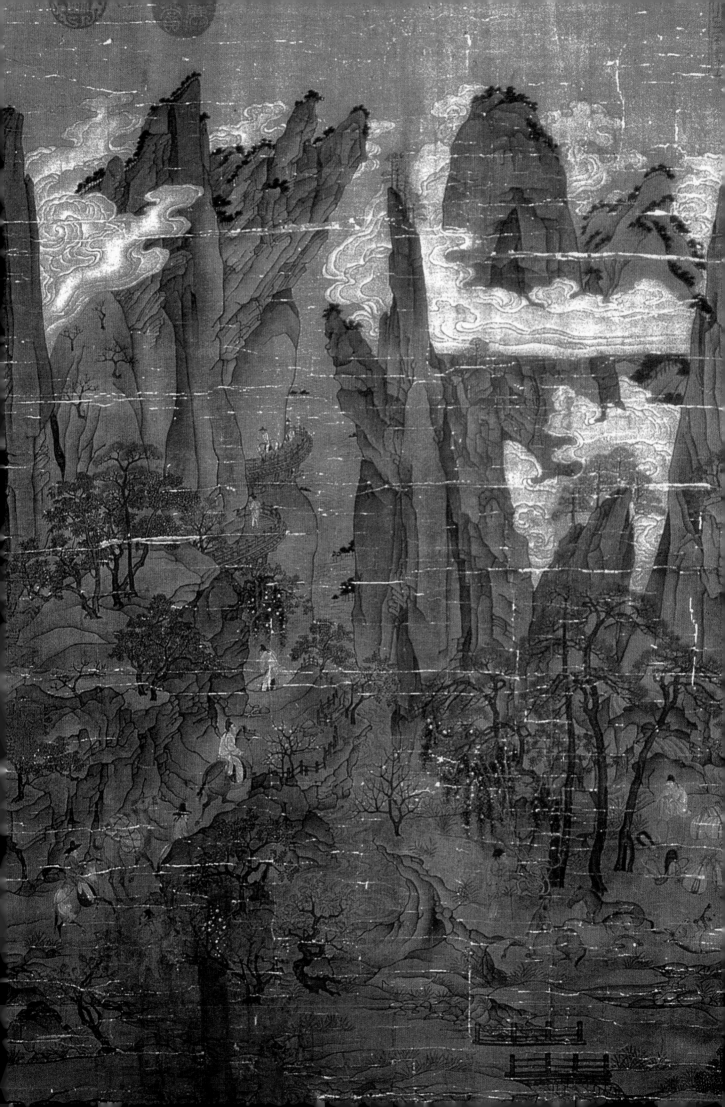

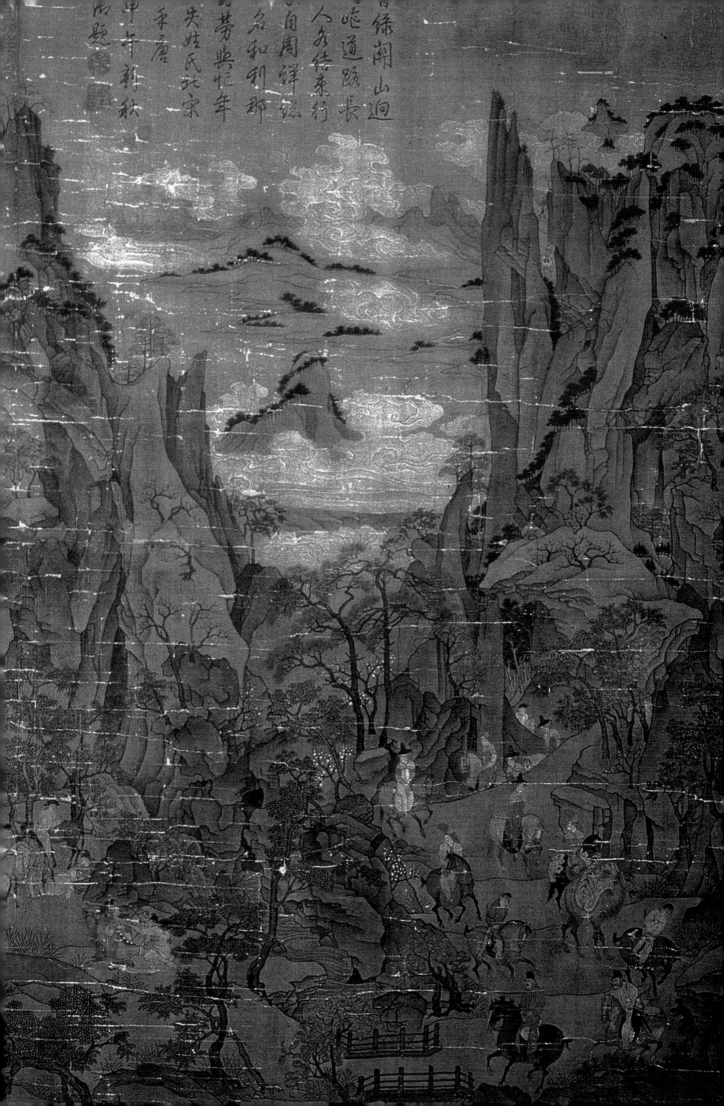

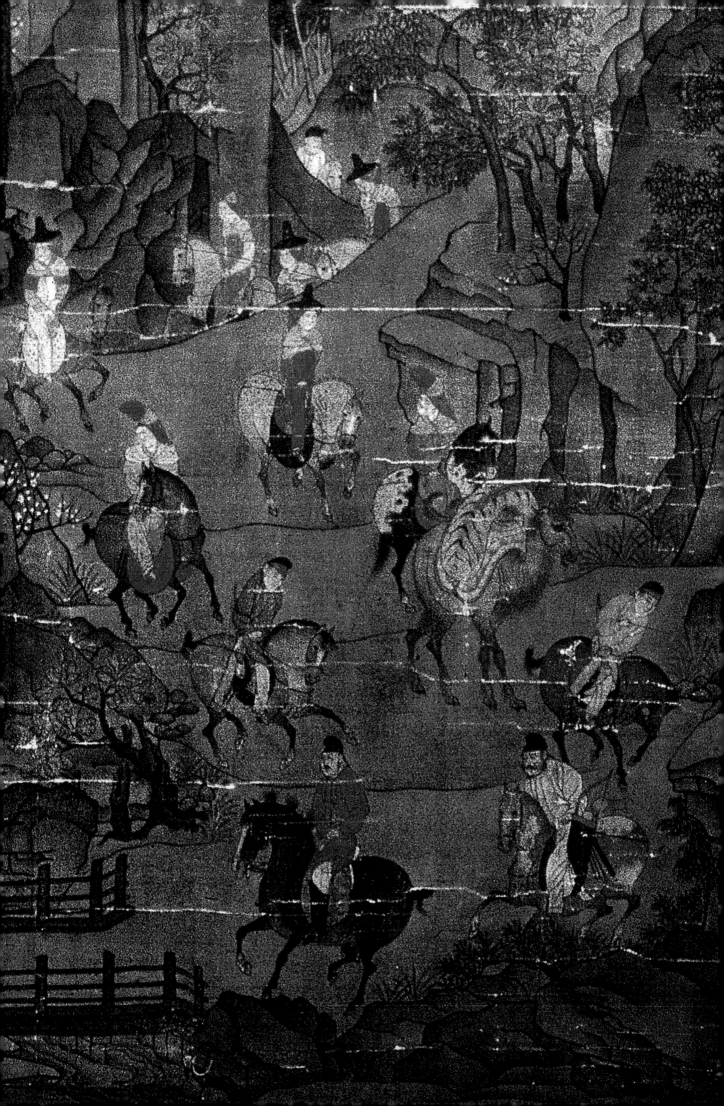

The famous poet and painter Wang Wei (699–759), father of the monochrome ink landscape style, was a master of both figure and landscape painting. Among the technical innovations attributed to Wang Wei are the use of washes, or "splashed ink," to create a sense of modeling and depth and the use of texture strokes to shade and model contour lines.

An anonymous landscape painting called *Ming Huang's Journey to Shu*, traditionally attributed to Li Zhaodao, is probably a faithful eleventh-century copy of an eighth-century composition. The painting depicts the flight of the emperor and his retinue through dangerous terrain en route to Shu (present-day Sichuan) after being driven from the cap-ital in 756. The small figures travel through an imaginary world dominated by fantastic mountain forms. For the sake of clarity, each group of figures in this shadowless world is neatly separated into its own space cell. Reflecting the Daoist idea that the immortals dwell in the mountains, stylized mist and clouds are used to represent the breath of the mountains that recede into the distance.

Another recurrent subject of Tang dynasty painting was the idealized portrayal of court ladies, as in the handscroll *Ladies Playing Double Sixes*, attributed to Zhou Fang. The refined court style was characterized by the careful arrangement of paired figures within a narrow stage-set space with little indication of background or setting.

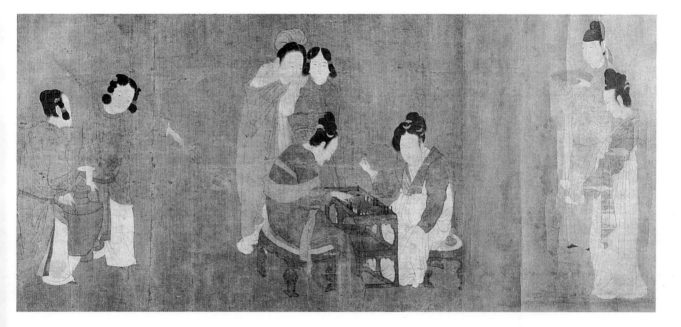

Ladies Playing Double Sixes

Attributed to Zhou Fang, Tang dynasty; section of handscroll: ink and colors on silk; 12½ in. high (31.7 cm). Freer Gallery of Art, Smithsonian Institution, Washington, D.C.

These court ladies are playing a board game similar to backgammon. Portrayed from various angles, the carefully-arranged, isolated figures are given only a gaming table to set the stage. The arc-shaped placement of the women surrounding the two central figures impart a sense of importance to the women's inconsequential activity—perhaps a comment by the artist on the frivolity of court life.

Emperor Ming Huang's Journey to Shu

detail; Tang dynasty; detail of a hanging scroll: ink and colors on silk. National Palace Museum, Taibei.

Ming Huang is pictured in the lower right area of the scroll, riding a horse whose mane is matted in three places, a convention reserved for imperial horses. Ming Huang's stable was said to have included over forty thousand horses.

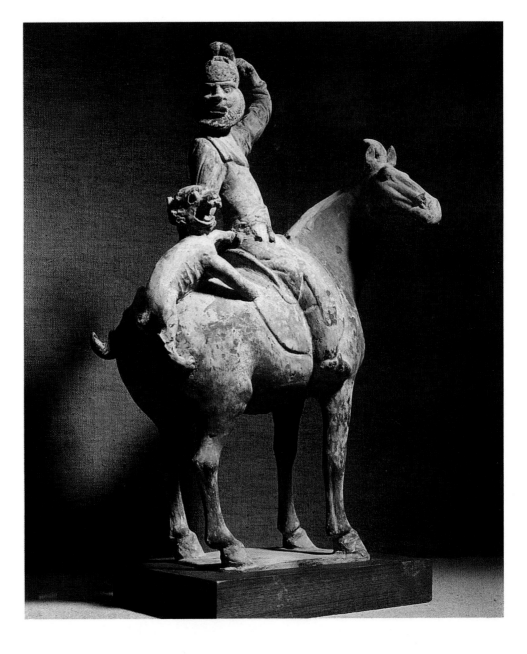

Tomb Figurine of a Mounted Hunter

From the tomb of Princess Yongtai, Qian Xian, Shaanxi province, Tang dynasty; painted earthenware; 12¼ in. high (31.5 cm). National Museum, Beijing. Chinese artists were fascinated by the thick beards, curly hair, and unfamiliar facial features of the foreign traders who flocked to the Tang capital. The many ceramic sculptures of foreigners with their horses and camels made at this time demonstrate the artists' keen powers of observation and senses of humor.

Paradise of Amitabha Buddha

From Dunhang, Gansu province, Tang dynasty; hanging scroll: ink and color on silk; 54 x 40 in. (137.1 x 101.6 cm). British Museum, London. Amitabha Buddha, seated in lotus position, is surrounded by bodhisattvas and monks. With Central Asian influences still evident in the modeling and shading of the figures, the rich details of this sumptuous paradise probably reflect the worldly splendor of the Tang capital at Chang'an.

Typically shown in a variety of poses, in frontal and three-quarter views seen from both front and back, the women in these paintings are much more robust in appearance than the wispy court ladies seen in compositions from the Six Dynasties. The appearance of this heavier type of figure in the secular arts may reflect a change in fashion with the new ideal of beauty set by the favorite concubine of Emperor Ming Huang.

Although historical records attested to the creation of great religious and secular paintings during this period, little was known of Tang Buddhist paintings until late in the nineteenth century when the first Westerner to visit one of the newly discovered caves at Dunhuang happened upon a

hidden, sealed depository that contained some five hundred paintings and prints along with more than ten thousand manuscript scrolls. Among these extraordinary works were hanging scrolls depicting the Paradise of Amitabha Buddha, the Buddha of the Western Paradise. According to the Pure Land school of Mahayana Buddhism, one simply needed to worship Amitabha Buddha faithfully to guarantee one's rebirth into the Western Paradise.

Superb earthenware tomb figurines in sizes ranging from a few inches to several feet account for a sizable proportion of the Tang ceramic production. The tomb of an emperor or high-ranking official might contain hundreds of clay soldiers,

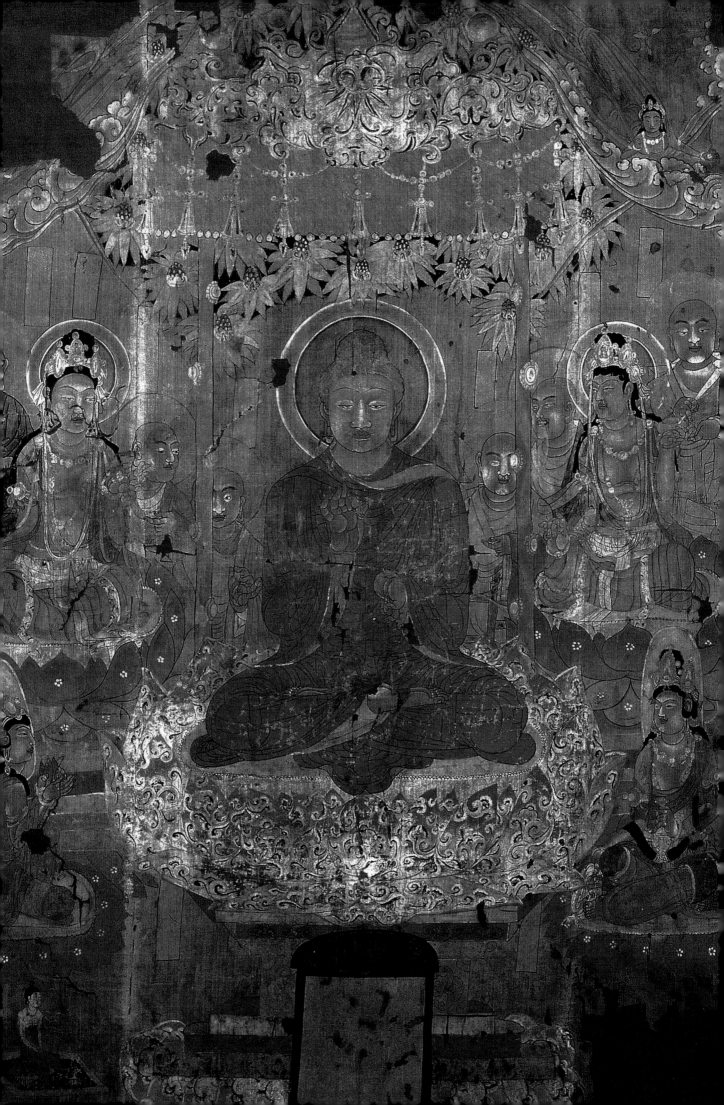

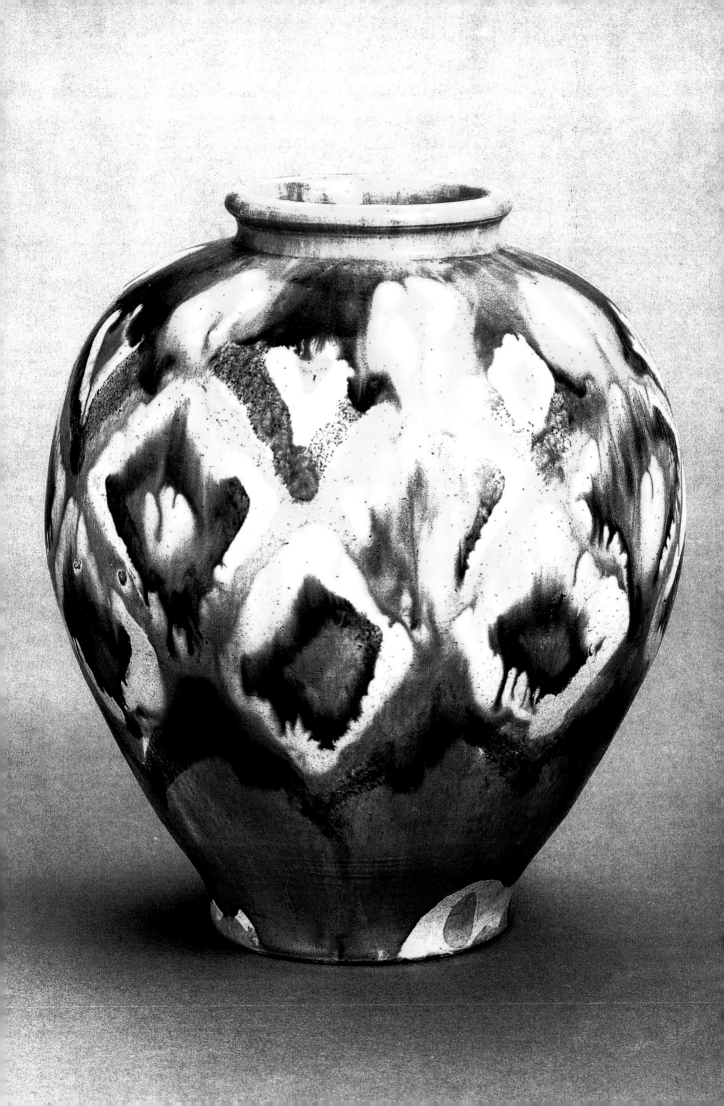

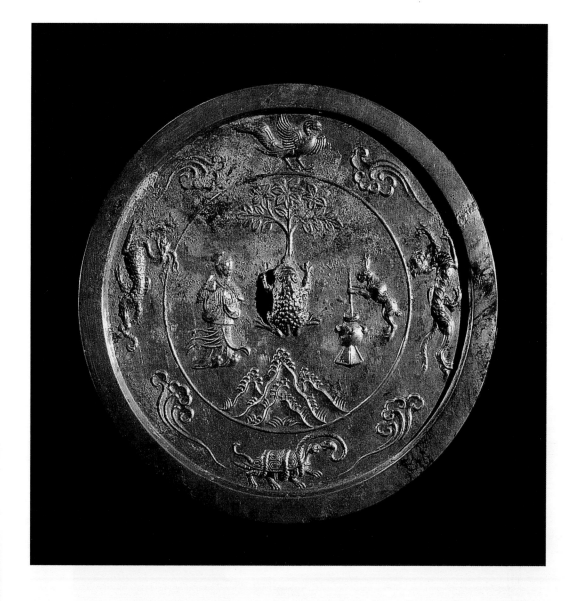

Mirror

Bronze, Tang dynasty.
Werner Forman Archive/
Art Resource, New York.
The rim on the back of
this mirror is embell-
ished with the Animals
of the Four Quadrants:
the Tortoise of the North
(winter), the Dragon of
the East (spring), the
Phoenix of the South
(summer), and the Tiger
of the West (autumn).
The hare in the center
symbolizes the moon.

Jar

Tang dynasty; three-color glazed
earthenware; 12 in. high
(30.5 cm). Purchase: Nelson Trust,
The Nelson-Atkins Museum
of Art, Kansas City, Missouri.
The three-color lead
glaze was usually allowed
to drip freely in the heat of
the kiln to produce sponta-
neous designs such as the
one seen on this jar. Surpris-
ingly, this brightly colored
glaze seems to have been
used exclusively on funerary
wares and tomb figurines.

servants, musicians, horses, and camels as well as
an assortment of everyday household goods. The
diverse panorama of Tang culture is reflected in
these sensitively crafted tomb figurines, which
include Greek acrobats, Semitic merchants, and
Central Asian musicians among many other exotic
figures. Ironically, the brilliant three-color glaze
that contributes to the charm of many of these
lively, naturalistic sculptures was reserved almost
exclusively for objects made specifically for
entombment.

Among the magnificent ceramic wares of the
Tang period were the first true porcelains and the
beautiful green-glazed stoneware known as

celadon. Tang potters had learned how to combine
kaolin clay with the proper proportions of feld-
spar and flint and then fire the clay at a suitably
high temperature to produce the hard, white,
translucent ceramic called porcelain. Some of the
robust shapes and intricate decorative motifs that
characterize the ceramic and metal wares pro-
duced by Tang artisans show the influence of Near
Eastern and Central Asian metalwork. These ele-
gant ceramics, along with a wide variety of exquis-
itely detailed metal boxes, cups, and bowls cast in
silver and embellished with gold, amply attest to
the cosmopolitanism and sophistication of the
Tang dynasty culture.

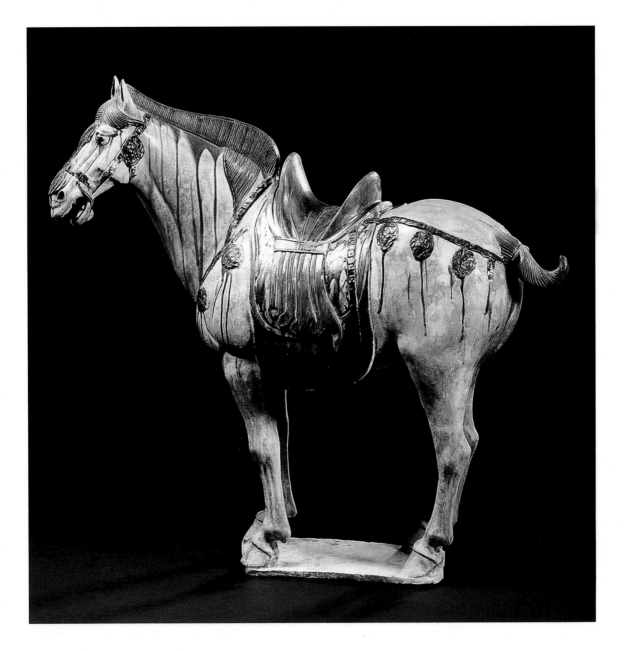

Tomb Figurine of a Saddle Horse

Three-color glazed earthenware; 29⅞ in. high (74.1 cm);
Tang dynasty. Victoria and Albert Museum, London.
Swift horses were of great advantage to the
Chinese cavalry guarding the western and north-
ern borders from nomadic invasion. Large tomb
figurines such as this elegant saddle horse are evi-
dence of the lavish burials of eighth-century China.

Tomb Figurine of a Bactrian Camel with Packsaddle

Tang dynasty; three-color glazed earthenware; 37 in. high (94 cm). Purchase:
acquired through the Joyce C. Hall Funds of the Community Foundation,
the Joyce C. Hall Estate, the Donald J. Hall Designated Fund of the Community
Foundation, the Barbara Hall Marshall Designated Fund, and the Elizabeth Ann
Reid Donor Advisory Fund, The Nelson-Atkins Museum of Art, Kansas City, Missouri.
Camels were important and familiar members of the many caravans
that traveled the Silk Route during this period of extensive trade.
Many ceramic figurines and paintings of camels, which came to
symbolize continued prosperity, were found in Tang dynasty tombs.

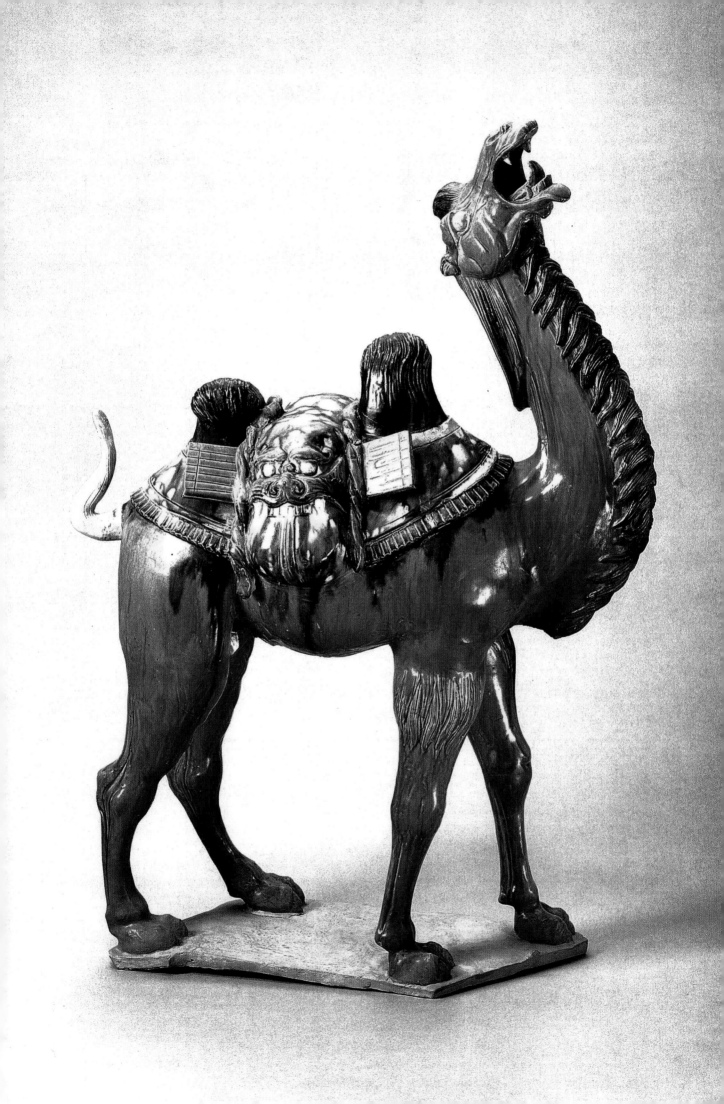

Bowl with Cover

*Tang dynasty; beaten silver
with chased and gilt deco-
ration; 9⅜ in. diameter
x 3¾ in. high (23.8 x 9.5 cm).
Seattle Art Museum.*

The cover of bowls
such as this were
designed to serve as
additional bowls when
reversed. Tang craftsmen
absorbed Persian tech-
niques and styles with
an emphasis on floral
designs. Earlier silver
work generally followed
Chinese bronze designs.

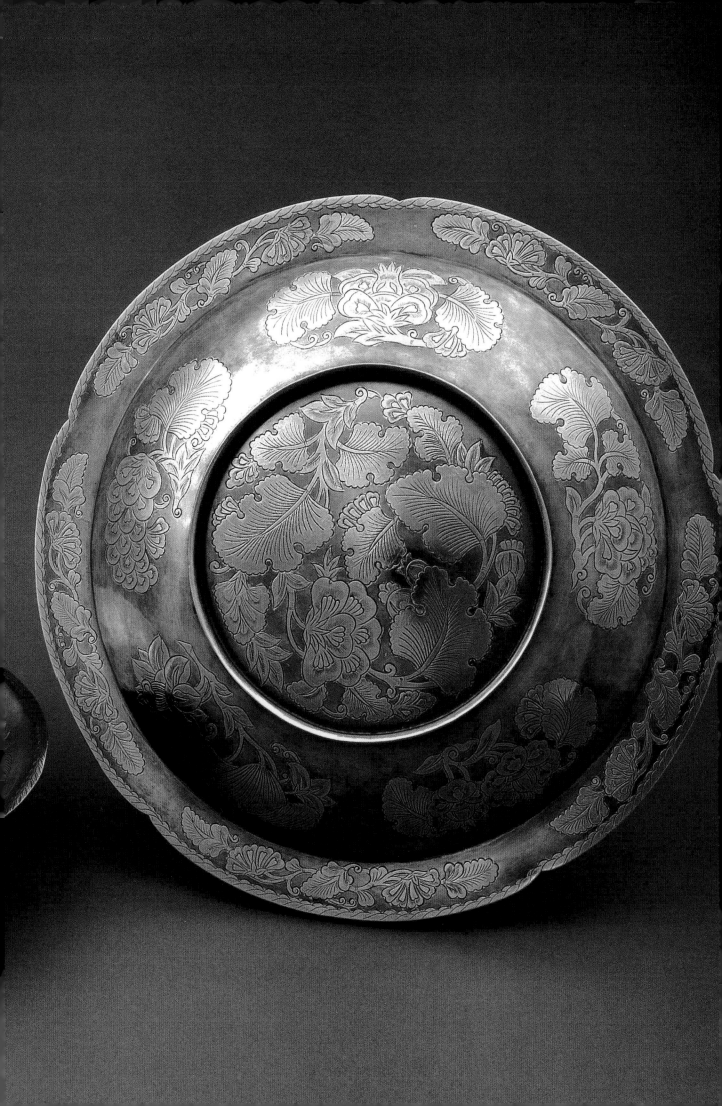

CIVIL UNREST AND FOREIGN THREATS

The end of the Tang period was a time of great economic and social upheaval in China. As the population moved steadily southward to seek new land, avoid taxation, and escape religious persecution, scattered rebellions broke out on the edges of the disintegrating empire. In 907, the last Tang emperor was deposed, and China was once again a divided land. Although this period of disunion was short-lived, threats to Chinese unity from both within and without would continue for many centuries to come.

Five Dynasties Period and the Liao Dynasty (907 – 960)

With the collapse of the Tang dynasty, China was once again split into unstable regional kingdoms. In the northeast, a semi-nomadic people called the Liao adopted many elements of Tang culture and established a capital at present-day Beijing. The rest of the country was ruled by a series of short-lived kingdoms referred to as the Five Dynasties and the Ten Kingdoms.

New styles of landscape painting emerged during this period of political unrest. Landscape painting, which appealed both to the Daoist sense of identification with nature and the Confucian concern with ordered relationships, replaced figure painting as the primary focus of Chinese painters. In his famous treatise on painting theory, the tenth-century landscape painter Jing Hao reasserted the primacy of Spirit Resonance as described by Xie He some four hundred years earlier: "Divine" paintings, wrote Jing Hao, are those in which the artist captures the spirit beneath the outward appearances of the landscape. Despite several centuries of stylistic changes, the fundamental principles by which Chinese painting was judged had remained exactly the same.

The new style of monochromatic ink landscape painting that emerged during the Five Dynasties period was less concerned with the depiction of human figures and historical narrative than Tang landscapes had been. The focus of the painting was now on the landscape itself, with emphasis placed on the brushwork and the multitude of small texture strokes used to build up the monumental mountains that were almost invariably depicted. In the tenth century, Dong Yuan and his pupil Ju-Ran chose to paint the moist and misty landscape of southeastern China rather than the dry and barren landscape of the north. The illusion of recession into space, as developed by Dong Yuan and Ju-Ran, was to become a major concern of all Chinese monumental landscape painters.

Li Cheng (c. 919–c. 967), one of the most influential landscape painters of the period, specialized in monumental winter landscapes. Painted with a texture stroke known as the "crab's claw," Li Cheng's twisted, gnarled, leafless trees and branches seem remarkably alive. The somber mood of these powerful paintings evoke the barren landscape of northern China.

Chan Buddhism (called *dhyana* in Sanskrit and *zen* in Japanese) was the most influential sect of Buddhism to have survived the religious persecution that took place toward the end of the Tang

Travelers Amid Streams and Mountains

detail; FAN KUAN, Northern Song dynasty; hanging scroll: ink and color on silk. National Palace Museum, Taibei.

Two tiny travelers can be seen driving four mules near the bottom of this large scroll where the mist creates a feeling of depth by separating the foreground from the massive mountains. Their diminutive size reflects the Daoist belief that man is just one small part of the universe.

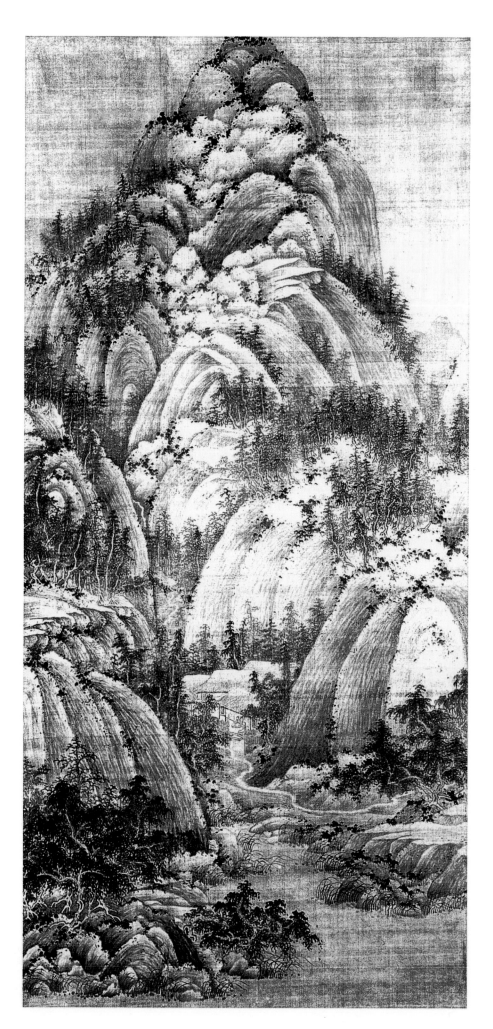

**Seeking the Dao
In the Autumn Mountains**

*Attributed to JU-RAN, Northern Song
dynasty; hanging scroll: ink on silk;
61½ x 30¾ in. (156.2 x 78.1 cm).
National Palace Museum, Taibei.*
The artist uses large, wet
brush dots to accent the
gently rounded hills. With
no single focal point com-
manding the entire painting,
the viewer's eye tends to
travel up the winding path in
order to read the landscape.

CIVIL UNREST AND FOREIGN THREATS

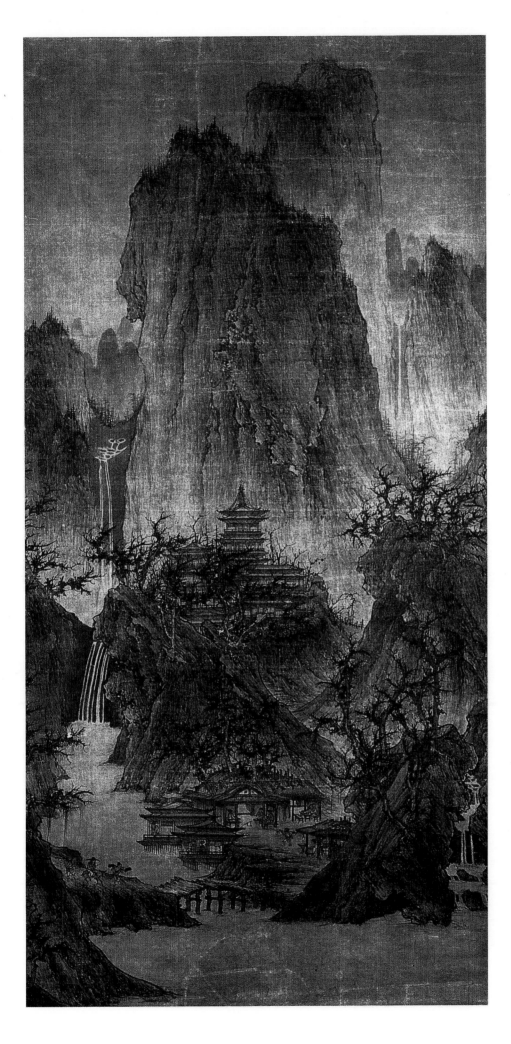

A Solitary Temple Amid Clearing Peaks

Attributed to LI CHENG, Five Dynasties period-Northern Song dynasty; hanging scroll: ink and slight color on silk; 44 x 22 in. (111.8 x 56 cm). Purchase: Nelson Trust, The Nelson-Atkins Museum, Kansas City, Missouri. Li Cheng emphasized the grand scale of his subject matter by painting the towering mountain as if it were too large to be confined within the borders of the painting. Clearly, the subject of this painting is the landscape itself. The temple cited in the title is merely incidental.

乾隆改元六月八日西蜀石恪寫

二祖調心圖

dynasty. First introduced into China in the sixth century, Chan Buddhism taught that meditation and self-discipline, rather than a reliance on ritual and scripture, were the true paths to enlightenment. In its elimination of foreign-looking images of the Buddha and the bodhisattvas, Chan Buddhism had great appeal to the Chinese people at a time when foreign ideas and religions were treated as suspect. A pair of hanging scrolls from this period, *Two Patriarchs Harmonizing Their Minds*, are the oldest extant examples of Chan Buddhist painting.

Patriarch and Tiger

Anonymous, in the manner of Shi Ke, one of a pair of hanging scrolls entitled "Two Patriarchs Harmonizing Their Minds," Five Dynasties period-Northern Song dynasty; ink on paper; 14⅓ x 25½ in. (36 x 64.7 cm). Tokyo National Museum.

The Buddhist holy man meditating atop a sleeping tiger represents the world in harmony. The vigorous movement of the rough, expressive lines of the man's garments—probably painted with straw or shredded bamboo instead of a brush—is a deliberate move away from the Chinese calligraphic fine-line tradition.

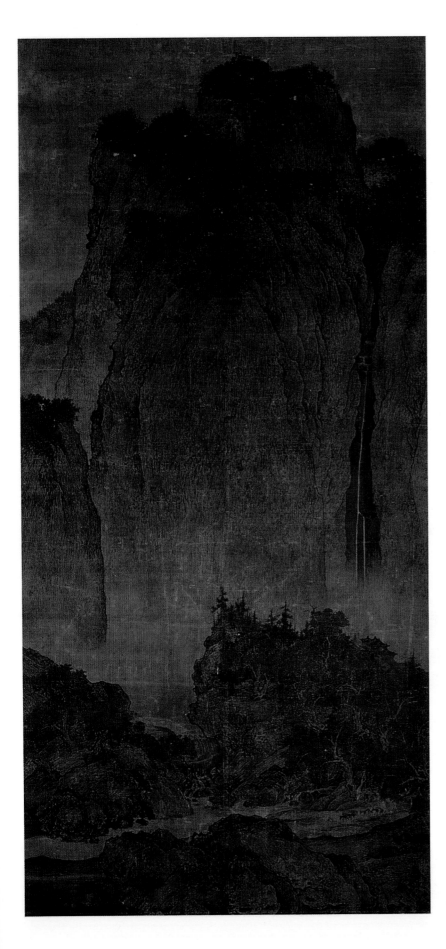

Northern Song Dynasty (960 – 1127)

Political disunity ended in 960 with the reunification of China under the first Song emperor. The new empire was smaller than that of the Tang, with the northeastern region of China remaining under Liao control. The Liao would eventually be conquered by the Jin, whose invasion of China in 1126 forced the court to flee from its northern capital near present-day Kaifeng and ushered in the southern period of Song rule.

In contrast to the cosmopolitanism of their Tang predecessors, Song rulers turned away from the outside world to seek inspiration in traditional Chinese values as expressed in the art and literature of antiquity. Great patrons of the arts, the Song emperors encouraged the collection and cataloguing of ancient bronzes, jades, and other artwork. Wood-block printing was used extensively to disseminate information about China's cultural heritage in handbooks and encyclopedias.

The growing influence of Neo-Confucianism—a reformulation of earlier Confucian, Daoist, and Buddhist ideas—brought with it a renewed reverence for nature that was to play a significant role in the evolution of landscape painting. To the Neo-Confucianist scholar, the moral principle, or *li*, was understood to be the essential congruence between every natural form and the Supreme Ultimate. By studying the natural world, men of cultivation hoped to gain a deeper understanding of what Daoists called simply "the Way." Thus, observing the landscape of the visible world and attempting to portray it in a painting were understood as valid paths to be followed in the ongoing quest for wisdom and spiritual growth.

Travelers Amid Streams and Mountains

FAN KUAN, Northern Song dynasty; hanging scroll: ink and color on silk; 81¼ x 40¾ in. (206.3 x 103.5 cm). National Palace Museum, Taibei. The artist's firm, deliberate brushwork, with his signature "raindrop" texture strokes uniformly used on the boulders and cliffs, displays a concentrated energy that makes the mountain appear to come alive. In this simplified composition, the distant cliffs usually depicted in monumental landscape paintings were eliminated.

Landscape painters of this period further developed the monumental landscape style that began in the Five Dynasties period. Fan Kuan (c. 990–1030), the master landscape painter of the early Northern Song Dynasty, lived in a barren area in the mountains of Shanxi province in northern China. Elaborating on the monumental landscape style of the Five Dynasties master Li Cheng, Fan Kuan is best known for his austere paintings of the landscape north of the Yellow River. His goal was to capture the life spirit (*qi-yun*) of nature itself rather than merely to portray its outer appearance. In *Travelers Amid Streams and Mountains*, the only surviving work painted in his own hand, Fan Kuan depicts a massive mountain that is even larger and bulkier than those seen in earlier monumental-style paintings. His skill in capturing the spirit of his subjects is reflected in the words of the eleventh-century painter and connoisseur Mi Fu, who observed: "In Fan Kuan's landscapes, you can even hear the water."

The landscape painter Guo Xi (c. 1020–c. 1090) was the head of the Imperial Painting Academy in the middle of the Northern Song period. He, too, followed the monumental tradition of Li Cheng, although his compositions were more complex than those of Fan Kuan. In his famous essay on landscape painting, *Lofty Message of Forests and Streams*, Guo Xi argued that landscape

paintings could substitute for reality, allowing viewers to feel as if they are actually in the place depicted in the painting. His masterpiece *Early Spring* uses an exaggerated, twisting mountain form, large wavering brushstrokes, shadows, and spatial ambiguities to depict a mysterious and turbulent world. Guo Xi effectively evoked the atmosphere of the real world, creating the illusion of deep space by using progressively lighter ink tones toward the top of the painting. This use of mood and atmosphere to convey a sense of realism would later be exploited by painters of the Southern Sung period.

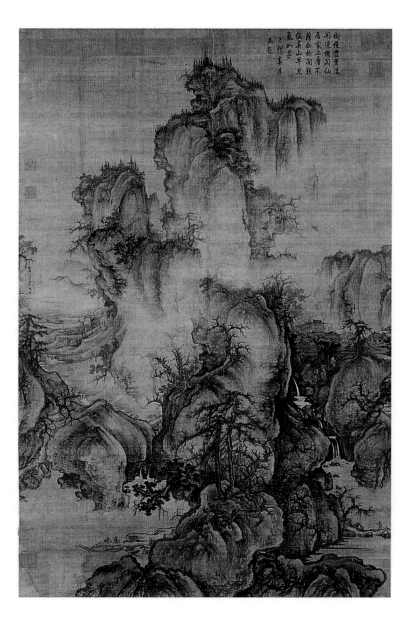

Early Spring

Guo Xi, dated 1072, Northern Song dynasty; hanging scroll: ink and slight color on silk; 62¼ x 42⅝ in. (158.1 x 108.2 cm). National Palace Museum, Taibei. Despite the erratic shifts in focus in the writhing mountain forms, the bare and spidery trees used throughout the scroll serve to unify the composition. The minuscule boatmen who appear in the empty space in the lower corners of the painting seem almost incidental to the composition.

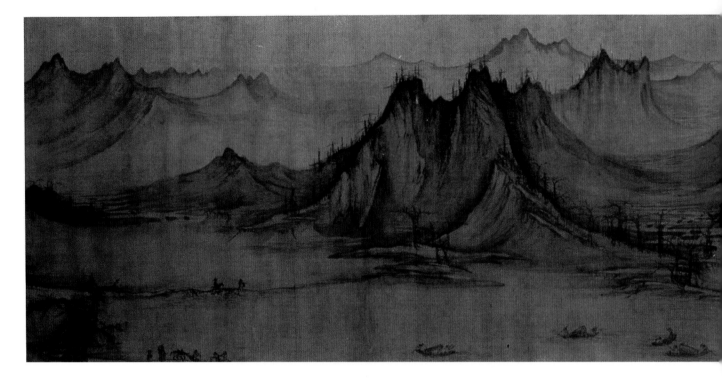

Xu Daoning (c. 970–c. 1052), the pupil of an Academy painter although not himself a member, also followed in the tradition of Li Cheng. In *Fishing in a Mountain Stream*, one of the finest surviving landscape handscrolls of the Northern Song period, Xu Daoning depicts a bleak northern landscape in which fishermen and travelers are dwarfed by sweeping cliffs and awe-inspiring mountains whose towering peaks extend even beyond the upper border of the scroll.

An important variation of the monumental style of landscape painting was developed by the painter Mi Fu (1051–1107) and his son Mi Youren (1072–1151). In the so-called "Mi style," misty landscape forms are built up by the application of large, wet dots of ink with the flat of the brush. This style of brushwork was particularly effective in rendering the misty landscape of the southern coastal region of China. The more spontaneous style of nonprofessional painters like Mi Fu and his followers was expressly rejected by the Song imperial court.

Although portraiture and landscape paintings were looked upon most favorably by contemporary critics, "fur and feather" painting—paintings of flowers, plants, birds, insects, and other animals—was enormously popular during this period as well. Emperor Hui Zong (1082–1135), the last Northern Song emperor to rule in Kaifeng, was a skilled painter and calligrapher who specialized in bird and flower paintings such as the charming *Five-Colored Parakeet on a Branch of a Blossoming Apricot Tree*. The emperor, who was an avid art collector, established the Song Imperial Painting Academy. The decorative style favored by Hui Zong and the Academy required the close observation of nature and meticulous attention to naturalistic details. The artists of the Academy rendered their plant and animal subjects by using a multitude of tiny brushstrokes much like those that landscape painters working in the monumental style used to build up their mountains. The result was a sort of "intellectual realism" that seems to render more detail in the painting than can actually be seen by the direct observation of nature.

Philosophically opposed to the Academic style were the literati painters, also known as scholar-painters, or *wen ren*. The literati were court officials who purposely distanced themselves from

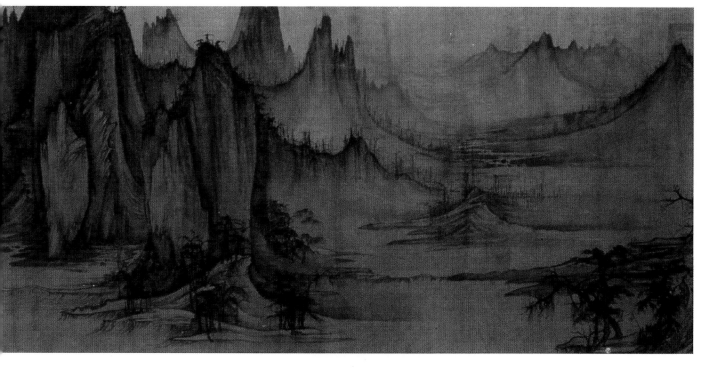

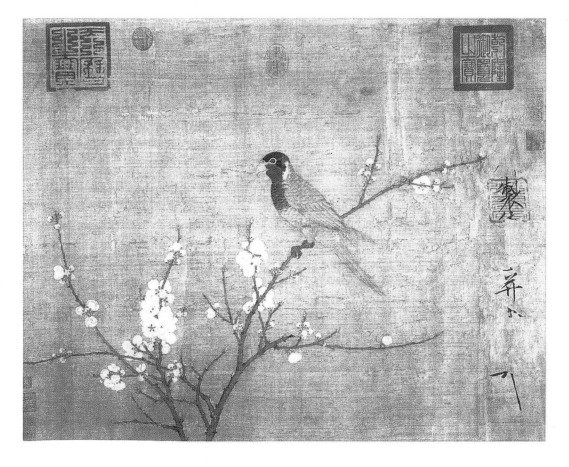

Five-Colored Parakeet on a Branch of a Blossoming Apricot Tree

Attributed to Emperor HUI ZONG, Northern Song dynasty; handscroll: ink and color on silk; 20¾ x 48¾ in. (52.7 x 123.8 cm). Museum of Fine Arts, Boston. While others painted monumental landscapes, the court painters of Hui Zong's Imperial Academy preferred intimate, finely-detailed depictions of birds and flowers. Although the emperor required the court painters to depict the literal appearance of their subjects, he expected them to transmit the subjects' essential spirit as well.

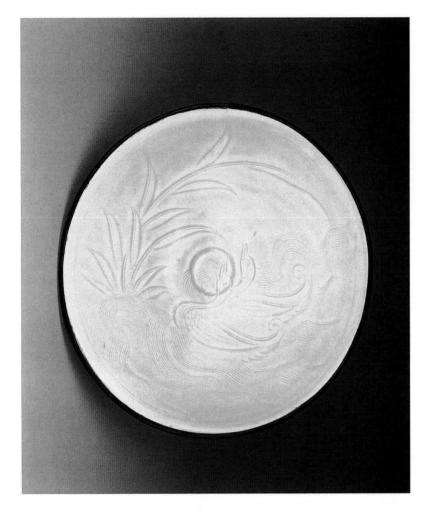

Bowl, *Ding* Ware

*Northern Song dynasty; porcelain
with incised design of ducks;
7⅞ in. diameter (20 cm).
Museum of Fine Arts, Boston.*
Ding wares were usually
fired upside down to
prevent their thin bodies
from warping, and the
resulting unglazed rim
would be bound with
precious metals. Deli-
cately incised, combed,
or molded designs of
flowers or animals are
often seen under the
ivory white glaze of
these finely potted wares.

the styles of the professional court painters and
the Academy. Practicing the arts of painting,
calligraphy, and poetry primarily for their own
pleasure, they were extremely reluctant to sell
their paintings and looked upon so-called
"professional" painters with disdain. The literati,
who almost always worked in monochrome ink
on paper rather than color on silk, considered
bamboo—a symbol of the purity and endurance
in the face of adversity that they strove to culti-
vate in themselves—to be an ideal subject for
their paintings.

They argued that the purpose of painting was
not to represent formal likeness by slavishly de-
picting reality but, rather, to express each painter's
unique thoughts and feelings; that is, their paint-
ings were intended to express the mind of the artist
and not to portray the superficial appearance of

mountains and trees. In the words of Su Shi
(1036–1101), the leading painter and poet of the
Northern Song literati: "If anyone discusses paint-
ings in terms of formal likeness, his understanding
is close to that of a child." Although the ideas of the
early *wen ren* had little influence on painting styles
during the Song period, they would be revived
in the late thirteenth century and remain a
tremendously important force throughout the
subsequent history of Chinese painting.

The Song dynasty was one of the richest periods
of ceramic production in Chinese history. Kilns
proliferated in response to a growing demand for
ceramics by a middle class that had gained wealth
and status as a result of the civil service examina-
tion system and the flourishing export trade.
Song ceramics, which were the first Chinese
ceramics to be produced under imperial patron-
age, are characterized by their simple, elegant
shapes, smooth, monochromatic glazes, and re-
strained ornamentation. Among the most refined
ceramics of the Northern Song were the thin,
creamy white porcelains with delicate incised or
molded decorations called *Ding* ware. *Ding* ware,
which had first appeared in a somewhat cruder
form during the Tang dynasty, is covered with
an ivory white glaze that sometimes runs down
toward the foot to form small streaks that resem-
ble teardrops. Infrequently, an iron-oxide glaze
would be applied to create black, brown, green,
purple, or red *Ding* ware.

Other ceramic wares of the Northern Song
period include *Ru* ware (a thick, gray-blue glazed
ceramic characterized by its fine crackle pattern),
Jun ware (a heavy ware thickly glazed in lavender
blue with purple splashes, purple with blue
streaks, or, less frequently, green), *Cizhou* ware (a
utilitarian, slip-decorated stoneware with painted
or incised ornamentation), and Northern
celadons (a gray-bodied, porcelaneous stoneware
characterized by its olive-green glaze and lively
carved or molded ornamentation). Thick-bodied,
black glazed tea wares, with subtle glaze effects
known as "hare's fur" or "oil spot," were also pro-
duced at this time. Prized for their ability to retain
heat, they inspired the Zen tea wares of Japan.

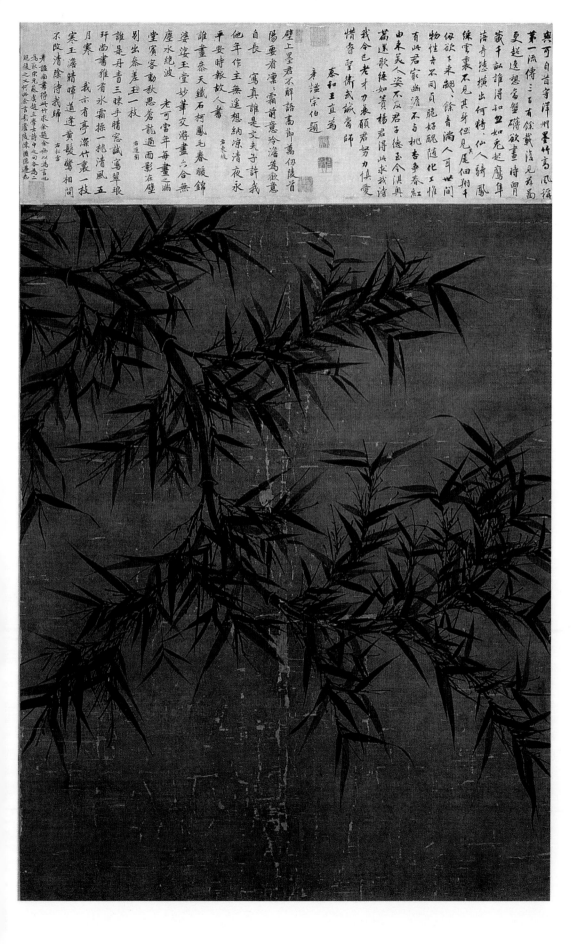

Bamboo

WEN TONG, Northern Song dynasty; hanging scroll: ink on silk; 52 x 41½ in. (132 x 105.4 cm). National Palace Museum, Taibei. The literati painters admired bamboo's ability to endure adversity and considered it the ideal subject for their paintings. Wen Tong, the first great master of bamboo painting, used rapid, calligraphic brushwork in this remarkable depiction of a curved branch in full leaf.

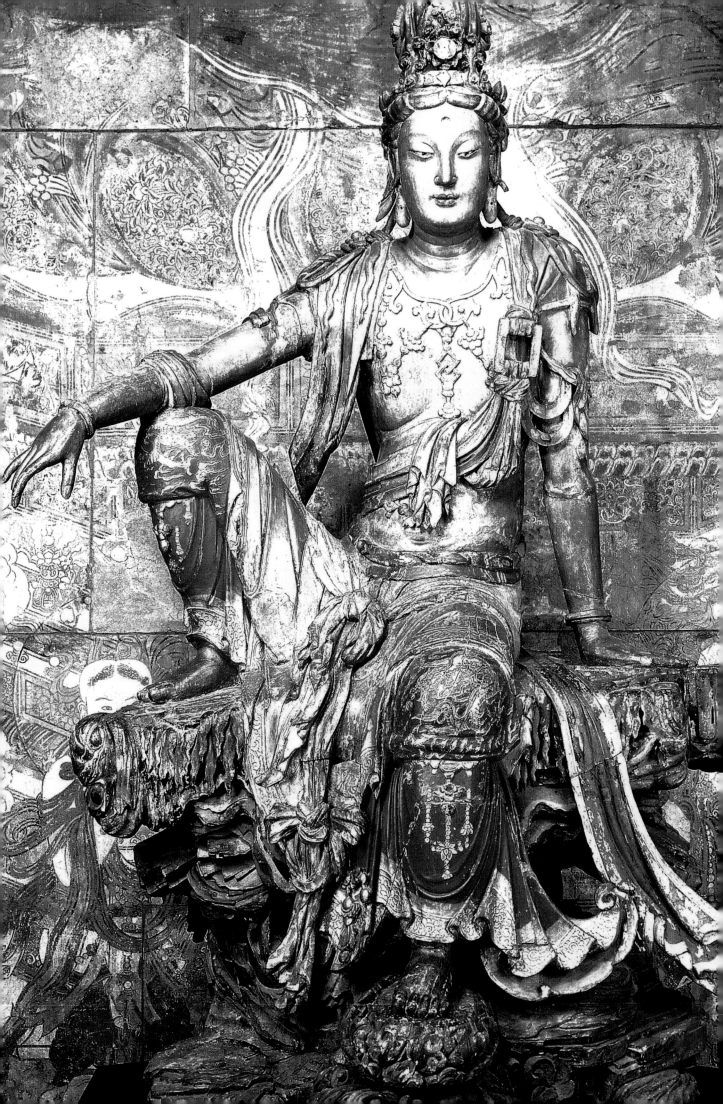

Southern Song Dynasty (1127 - 1279)

When most of the Northern Song territory, including the capital at Kaifeng, was conquered by the Jin in 1127, the Song court fled south and established a new capital at Hangzhou. Under the descendants of Emperor Hui Zong, the Academy was reestablished, and a new imperial art collection was assembled.

Buddhist sculpture proliferated under the Song, although much of what survives was made in the north under Liao and Jin rule. The most popular Buddhist figure in China was Guanyin, the bodhisattva of mercy and compassion, who became increasingly feminine in form and character after his importation from India to China. A decidedly feminine-looking wood image of Guanyin (known as Avalokiteshvara in Sanskrit) seated in the pose of royal ease shows lively, swirling drapery and a warm smile. The vitality and inventiveness of this sensuous sculpted image has no counterpart in conservative Buddhist painting.

Magnificent ceramics continued to be produced during the Southern Song period. Longquan celadons, with their elegant forms and thick,

Vase

Southern Song dynasty; Longquan celadon, porcelaneous stoneware; 10⅛ in. high (25.7 cm). Freer Gallery of Art, Smithsonian Institution, Washington, D.C.

Although Longquan celadons are characterized by their lustrous, jade-like glazes and are typically devoid of crackle, the potter who made this beautiful blue-green vase decided to experiment with the controlled use of crackle. Perfectly proportioned fish-shaped handles complement the simple, undecorated surface of the vase.

The Water and Moon Guanyin

Northern Song or Liao dynasty, 11th to 12th century; painted wood; 95 x 65 in. (241.3 x 165.1 cm). Purchase: Nelson Trust, The Nelson-Atkins Museum, Kansas City, Missouri.

Based on a Buddhist sutra that describes Guanyin as sitting in a rocky grotto watching the moon's reflection in the water, this ornate wooden sculpture depicts the deity of mercy and compassion arrayed in the sumptuous clothing of a bodhisattva and seated in the position of royal ease.

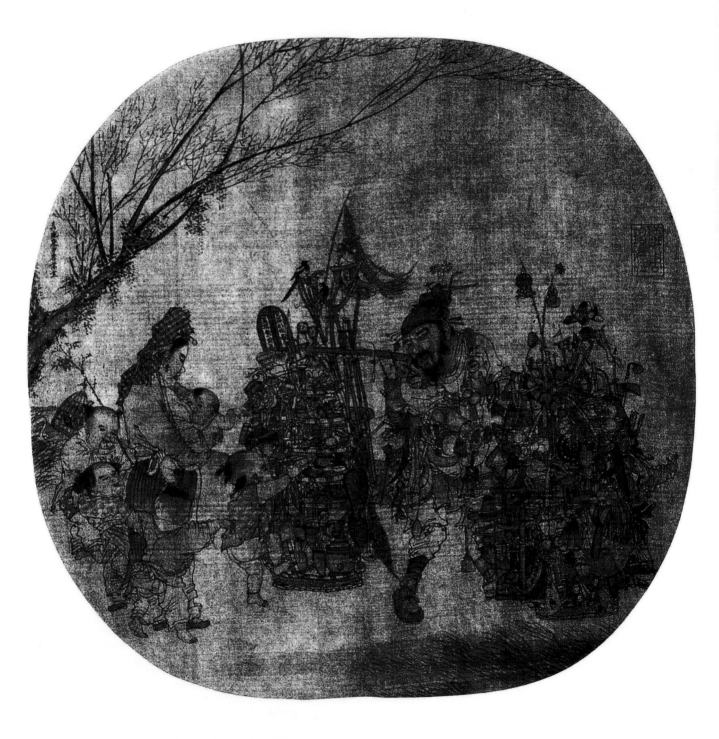

The Knick-Knack Peddler

LI SUNG, Southern Song dynasty, dated 1210; album leaf: ink and light colors
on silk; 10⅛ x 10⅞ in. (25,7 x 27.6 cm). National Palace Museum, Taibei.
In this charming character study, Li Sung depicts an apprehensive peddler who is
trying to make a sale to a woman overwhelmed by her demanding children. Circular
or oval shaped fan paintings, typically done by the best painters at the court, were
often inscribed on the back with poetry written by a member of the Imperial family.

Walking on a Path in Spring

MA YUAN, Southern Song dynasty; album leaf: ink and light colors on silk; 10¾ x 17 in. (27.3 x 43.1 cm). National Palace Museum, Taibei. In this asymmetrical composition, the glance of the scholar and the diagonal line of the tree limb lead the viewer's eye to the bird who has just flown off into distant space. The artist focuses on a very small detail of the landscape to represent an idealized world that eliminates the unessential.

lustrous glazes, and Guan ware, characterized by its induced crackle pattern, were among the most impressive of these tastefully understated ceramics. Both Longquan celadon and, to an even greater extent, Guan ware reflect the Chinese ceramicists' desire to emulate the sensuous look and feel of jade.

The rulers of the Southern Song encouraged the continuation of Northern Song painting traditions that predated the overthrow of Chinese rule in the north. "Fur and feather" painting flourished, albeit in a somewhat softer and less literal form than earlier animal and flower paintings. Figure painting focused on both secular subjects and genre scenes, and paintings of children were especially popular. *The Knick-Knack Peddler*, a fan-shaped album leaf by the Academy painter Li Sung, is a masterpiece of draftsmanship. An inscription by the artist explains that the peddler is balancing "five hundred articles" on his back, and the profusion of wares is meticulously delineated by the artist. Li Sung was undoubtedly proud of the great number of individual objects he was able to clearly depict, although five hundred is certainly an exaggeration. The implied chaos of the scene may have been a subtle comment on the political problems plaguing the Song royal house.

Ultimately, the monumental landscape style favored by the Northern Song masters proved unsuitable to the gentler landscape of southern China. Li Tang, a Northern Song Academy painter who moved with the court to Hangzhou, played a transitional role in modifying the monumental style. Ma Yuan and Xia Gui, two Southern Song court painters who were followers of Li Tang, developed a more intimate, lyrical style of landscape painting. The Ma-Xia style used ink washes in asymmetrical compositions to create the misty, atmospheric effects that conveyed the feeling of the southern landscape. The evocative paintings they produced were greatly admired in Japan, where the style was widely copied. Ma Yuan earned the nickname "one-corner Ma" by painting compositions that were split diagonally with most of the precise brushwork massed into one corner, counterbalanced by delicate ink washes used to represent limitless space in the opposite corner. The paintings of Xia Gui also exhibited the one-corner style but were bolder, more hazily atmospheric, and used simplified, silhouetted forms.

Other painters of the Southern Song period combined the Ma-Xia preference for monochrome ink, enlarged detail, and calligraphic brushwork, with the Daoist and Chan Buddhist focus on responding to nature in an intuitive and

The Fragrance of Spring: Clearing After Rain

MA LIN, Southern Song dynasty; album leaf: ink and light colors on silk; 10¾ x 16⅜ in. (27.3 x 41.5 cm). National Palace Museum, Taibei. Painted at a time when the Southern Song government was highly unstable and foreign invasion was imminent, this unconventional depiction of an untidy world beginning to regenerate itself at the start of spring reflects a society in disarray and badly in need of renewal.

spontaneous manner. Emphasizing instantaneous enlightenment without reliance on ritual, deities, holy images, or scriptures, Chan Buddhism inspired a new style characterized by boldness of composition and rapidity of execution. Mu Qi, the abbot of one of the Chan monasteries located in the hills around Hangzhou, painted landscapes and flowers as well as specifically Buddhist subjects in an effort to portray the essential Buddha-nature inherent in all things, including his famous *Six Persimmons*. The rapid and spontaneous brushwork of painters like Mu Qi and Yu-Jian reflects the Chan idea that enlightenment comes not through the laborious study of ancient scriptures but, rather, in a flash of realization.

Liang Kai, another master of the spontaneous Chan style, turned to Chan Buddhism after resigning from the Southern Song Painting Academy. Liang Kai painted figures, landscapes, and both Daoist and Buddhist subjects. His famous abbreviated brushwork technique, with its spontaneous

application of ink, is especially evident in his idealized portrait of the Tang poet Li Taibo.

With its emphasis on one-to-one transmission of Buddhist teachings, Chan Buddhism elicited detailed portraits of Chan masters that were painted in the conservative Tang figure style, which was also used for portraits of Daoist sages and political figures. These portraits of Chan masters were often presented to pupils at the conclusion of their training to enable them to take a reminder of their teacher with them upon leaving the monastery.

As the Mongol threat from the north began to undermine the security of the Southern Song dynasty in the mid-thirteenth century, the romanticism reflected in the Ma-Xia style of Academy landscapes was increasingly tempered by feelings of tension and anxiety. This sense of disorder and instability is dramatically evoked in *The Fragrance of Spring: Clearing After Rain*, an album leaf painted by Ma Lin, the son of Ma Yuan.

Mountain Village in Clearing Mist

*YU-JIAN, Southern Song dynasty; section of a handscroll: ink on paper;
11⅞ x 32⅞ in. (30.1 x 83.5 cm). Idemitsu Museum of Arts, Tokyo.*
Chan paintings such as this "splashed ink" painting by
the monk Yu-Jian were treasured and preserved by Zen
Buddhists in Japan. This highly abstracted landscape is
one of three surviving segments of a larger handscroll.

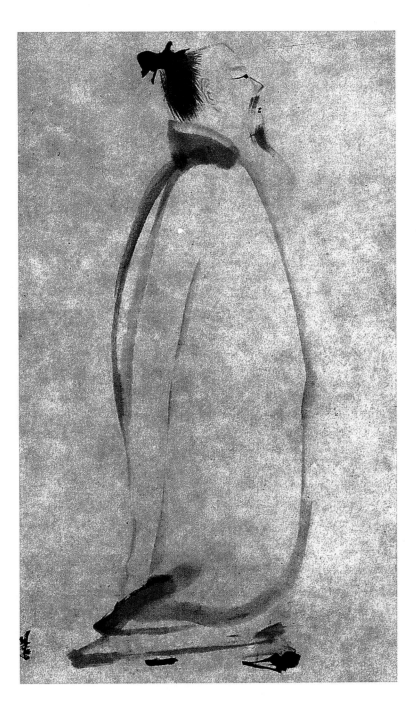

The Poet Li Taibo

*LIANG KAI, Southern Song dynasty;
hanging scroll: ink on paper;
31⅔ x 12⅛ in. (80.4 x 30.7 cm).
Tokyo National Museum.*
In this extraordinary example
of Chan painting, Liang Kai
uses fluid, economical brush-
work to delineate the robe of
the famous Tang Dynasty poet
Li Taibo, who is seen here chant-
ing a poem. The rapidly executed
brushwork reflects the Chan idea
of spontaneous enlightenment.

Home Again

QIAN XUAN, Yuan dynasty; handscroll: ink and color on paper; 10 ¼ x 42 in. (20 x 106.7 cm). Gift of John C. Ferguson, 1913, The Metropolitan Museum of Art, New York. Painted in the archaic blue-and-green style that was popular during the Tang dynasty, this handscroll depicts a disgruntled scholar-official returning to his country home after leaving government service.

Yuan Dynasty (1279 – 1368)

By 1234, the Mongols, led by Genghis Khan, had overthrown the Jin dynasty and laid waste to much of northern China. The Song capital at Hangzhou finally fell to Genghis Khan's grandson, Kubilai Khan (1260–94) in 1276. Within three years, the Mongols had gained control of the entire country, uniting China under foreign rule for the first time. Kubilai Khan, the first emperor of the Yuan dynasty, moved the winter capital to present-day Beijing while keeping his summer capital at Shangdu—the inspiration for Coleridge's Xanadu—in what is now Inner Mongolia. It was at this time that the writings of Marco Polo, the famous traveler who spent over two decades in the service of Kubilai Khan, provided many Europeans with their first real glimpse into Far Eastern civilization.

China was now part of a vast empire that extended from Korea in the east to Persia in the west. New ideas and cultural influences streamed into China from abroad, including the esoteric sect of

Tantric Buddhism practiced in Tibet and Inner Mongolia, and the effect of those influences are reflected in the Buddhist art of the period.

An admirer of Chinese culture, Kubilai Khan was a capable ruler who tried to repair the empire's war-ravaged economy while patronizing the traditional Chinese arts. At the same time, however, he reinforced Mongol sovereignty by abolishing the civil examination system and discouraging Chinese scholars from entering government service. Resentful of the foreign conquerors who had corrupted their government and contaminated their culture, many Confucian scholars retired into private life to devote themselves full-time to the pursuit of art and literature.

The literati painting tradition, which had been dormant since the early Southern Song, was revived by these retired scholars who, under Chinese rule, would have occupied important governmental positions. Forced out of their traditional Confucian roles, many of them chose to live as recluses near Hangzhou, where they spent their days paint-

ing, writing poetry, and practicing calligraphy. Wishing to disassociate themselves from the disgraced Southern Song, the literati rejected both the romanticism of the Ma-Xia school and the rough, spontaneous style of the Chan Buddhist artists. Looking further back into history, they drew their inspiration from the golden days of the Tang dynasty.

Despite their disdain for the Mongol conquerors, artists who were summoned to work at the court of Kubilai Khan had little choice but to heed the call. The painter Qian Xuan, once a scholar-official in the Southern Song court, was excused from service when he claimed to be too old to make the arduous trip from Hangzhou to Beijing. Perhaps best known as a "fur and feathers" painter, Qian Xuan developed a style combining Song realism and archaic Tang painting styles. Qian Xuan's handscroll *Home Again*, based on a poem written in the early fifth century, subtly signaled the painter's yearning to return to the days when China was under native rule.

Zhao Mengfu (1254–1322), a pupil of Qian Xuan's, was descended from the Song Imperial family. After ten years of retirement, Zhao Mengfu joined the Mongol court in Beijing and, to the dismay of his contemporaries, served as a high-ranking official under Kubilai Khan. Rejecting the refined realism and romanticism of the Southern Song Academy, Zhao Mengfu shunned naturalism and the depiction of outer beauty. By emphasizing the abstract rhythms and textures of his brushwork, he made it clear that the true subject of his painting was the brushwork and not the particular subject matter he chose to depict. A brilliant scholar, painter, and calligrapher, Zhao Mengfu was much admired by the literati for his ability to express his own personality in his paintings.

The Yuan dynasty began to decline rapidly after the death of Kubilai Khan. It was during these final years of the dynasty, when Chinese scholars were increasingly withdrawing from official service, that the Four Great Masters of the Yuan dynasty—Huang Gongwang, Wu Zhen, Ni Zan, and Wang

FOLLOWING PAGE:

Autumn Colors on the Qiao and Hua Mountains

ZHAO MENGFU, dated 1296, Yuan dynasty; handscroll: ink and color on paper; 11¼ x 36¾ in. (28.5 x 93.3 cm). National Palace Museum, Taibei. Zhao Mengfu's emphasis on brushwork rather than on the depiction of an idealized landscape set the style for the Yuan dynasty literati painters who followed. The artist's inscription explains that the handscroll was painted for a friend who longed to return to his home in the north.

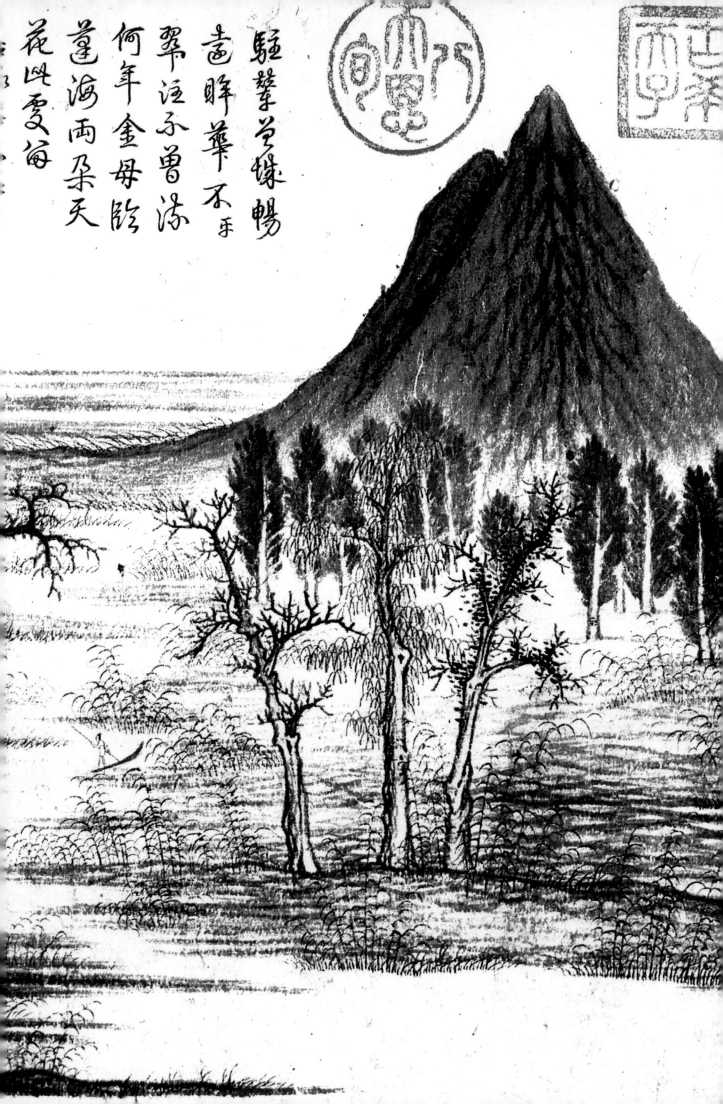

駐蹕芳塍暢
畫眸華不平
翠涯不曾染
何年金母餞
蓬海兩朵天
花映雲海

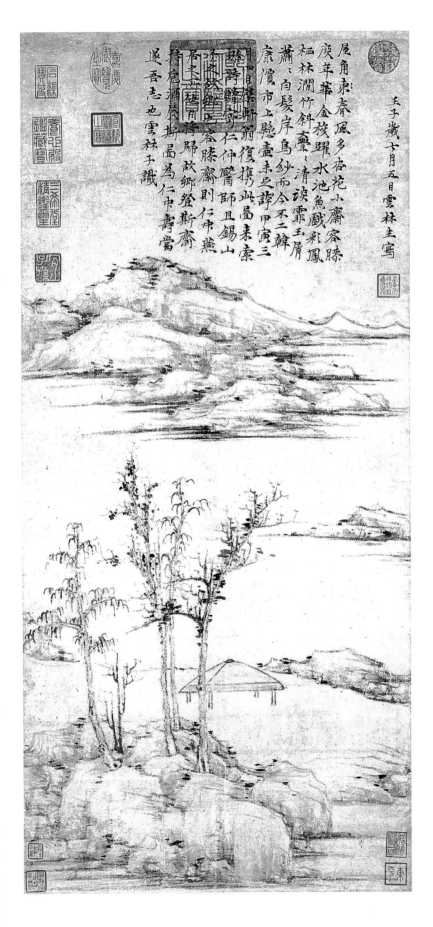

Meng—reinvigorated the literati painting tradition. The literati focused primarily on landscape painting, with a strong preference for painting on paper rather than silk. Their landscapes were intended not as literal depictions of actual places but, rather, as intellectual conceptions of landscape. They rejected representational accuracy and professionalism in paintings, focusing instead on calligraphic brushwork and the expression of the individual artist's thoughts and feelings.

Huang Gongwang, the oldest of the Four Great Masters, became a Daoist priest after retiring from a minor government post. His most famous and influential work, *Dwelling in the Fuchun Mountains*, shows his mastery of the brush and his total disregard for the landscape conventions of the Academy. Bold but simple brushwork was also the trademark of Wu Zhen, the second of the Four Great Masters.

Ni Zan (1301–1374), the third of the Four Great Masters, was the paragon of the scholar-painter ideal, and his stylistic innovations were endlessly imitated by other painters. Born into a wealthy family, Ni Zan gave up his fortune to live simply on a houseboat until the re-establishment of Chinese rule in 1368. In his delicate, luminous landscapes, Ni Zan depicted an austere world conspicuously devoid of people. The artist's sparing use of ink inspired the observation that Ni Zan treasured ink like gold. When someone complained that a bamboo painting Ni Zan had made while he was drunk didn't look like bamboo, Ni Zan replied, "Ah, but a total lack of resemblance is hard to achieve; not everyone can manage it." The unique rock formations at the Lion Grove Garden in Suzhou, which Ni Zan painted toward the end of his life, proved to be an excellent subject matter for this highly individualistic and tradition-defying master.

The Rongxi Studio

Ni Zan, dated 1372, Yuan dynasty; hanging scroll: ink on paper; 29⅜ x 14 in. (74.6 x 35.5 cm). National Palace Museum, Taibei. This austere composition, with a river bank and a few trees in the foreground, distant hills in the background, and an empty middle ground representing a broad expanse of water, demonstrates a manipulation of landscape elements that is not overly concerned with depicting any formal likeness of the real world.

Dwelling in the Fuchun Mountains

HUANG GONGWANG, dated 1350, Yuan dynasty; detail of handscroll: ink on paper; 12⅞ x 251 in. (32.7 x 637.5 cm) National Palace Museum, Taibei. Painting in his old age, Huang Gongwang reported that he laid out the overall design of this long handscroll in "one burst of creation." Using an additive technique in which multiple, successive applications of ink were applied, the artist took three years to complete the painting.

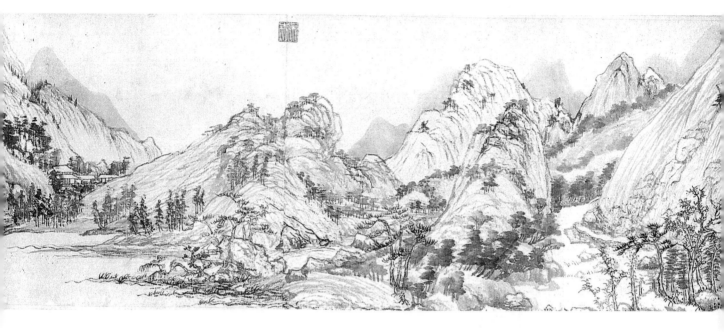

Lion Grove Garden (*Shizi Lin*)

View west to Heart of the Lake Pavilion; Suzhou, Jiangsu province, Yuan dynasty with later additions. Photograph by Dennis Cox, ChinaStock. The beautiful Lion Grove Garden remains a popular attraction for visitors to Suzhou. Originally designed by a group of famous artists and architects in 1342 as part of the grounds of a temple, the garden includes numerous lakes, hills, caves, and unusual rock formations that are said to resemble lions.

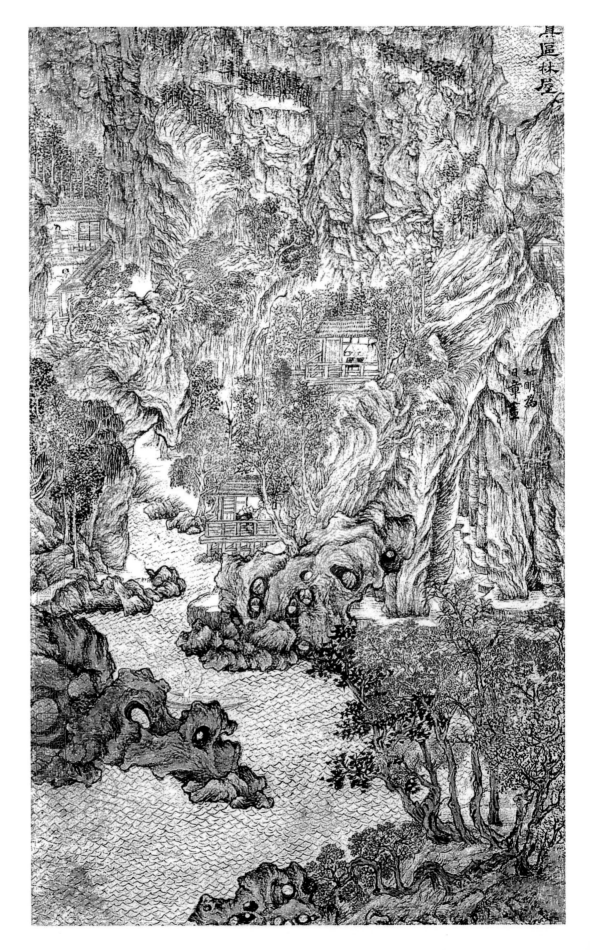

**Forest Grotto
at Juqu**

*WANG MENG, Yuan dynasty;
hanging scroll: ink and color
on paper; 27⅛ x 16¾ in.
(68.8 x 42.5 cm). National
Palace Museum, Taibei.*
The artist placed build-
ings and figures in iso-
lated areas of the densely
textured landscape, sug-
gestive of the space cells
used in archaic paint-
ings. The turbulent, ex-
pressionistic world of
Wang Meng's paintings
is based on the inner vi-
sion of the artist rather
than on external reality.

The youngest of the Four Great Masters was Wang Meng, a grandson of Zhao Mengfu. Inspired by the monumental landscape style of the Five Dynasties and Northern Song periods, Wang Meng developed a style that was the virtual antithesis of Ni Zan's spare and delicate approach to landscape. Wang Meng filled the entire surface of his paintings with rich and varied brushstrokes. The restless exuberance of his twisting, powerful forms and his skillful balancing of densely textures masses of color can be seen in compositions such as *Forest Grotto at Juqu*.

Despite a decline in court patronage of fine wares, ceramics of the Yuan period continued to be exported extensively to India, Southeast Asia, Japan, the Philippines, and the Middle East. The kilns at Jingdezhen in Jiangxi province, which began producing porcelains in the tenth century, remained the center for porcelain production, and it was there that the new and innovative technique of underglaze painting in cobalt blue and, more rarely, copper red was first developed. Originally imported from the Near East, cobalt blue pigment was applied directly to the clay body with a brush before glazing and firing. The advent of underglaze blue-and-white wares was accompanied by a decrease in the production of the blue-tinged *qingbai* (literally "blue-white") wares, which had been produced since the tenth century.

Pair of Incense Burners

Probably from kilns in the vicinity of Jingdezhen, Jiangxi province, Yuan dynasty, early fourteenth century; Qingbai ware, porcelain; 8¾ in. high (22.2 cm). Fletcher Fund, The Metropolitan Museum of Art, New York.

Qingbai (literally, "blue-white") wares are characterized by a delicately tinted glaze that deepens in tone where it pools in carved designs. Later examples, such as these incense burners, were generally bolder and more elaborate in their decoration.

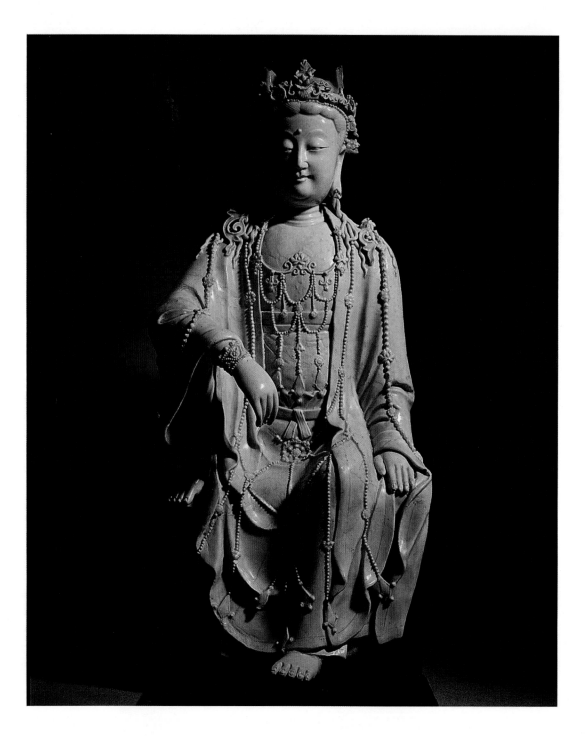

Bodhisattva Guanyin

*Yuan dynasty, 14th century; porcelain Qingbai ware;
26⅛ in. high (67 cm). National Museum, Beijing.*
This elegant porcelain figurine of a be-
jeweled Guanyin, excavated in the remains
of the Yuan capital Dadu (present-day
Beijing), was probably used in a domestic
shrine.

Temple Vase

*Probably from Jingdezhen kilns, Jiangxi province, Yuan dynasty, dated 1351; porcelain
painted in underglaze blue. Percival David Foundation of Chinese Art, London.*
This large temple vase with elephant-head handles displays
vigorous brushwork in underglaze blue that appears almost
black where the cobalt blue is highly concentrated. One of a
pair, this magnificent vase testifies to the mastery of the Chinese
artisans at this early stage of the underglaze blue technique.

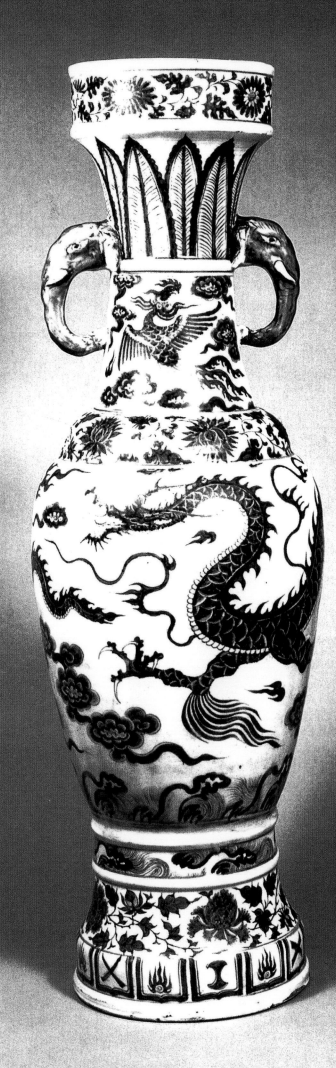

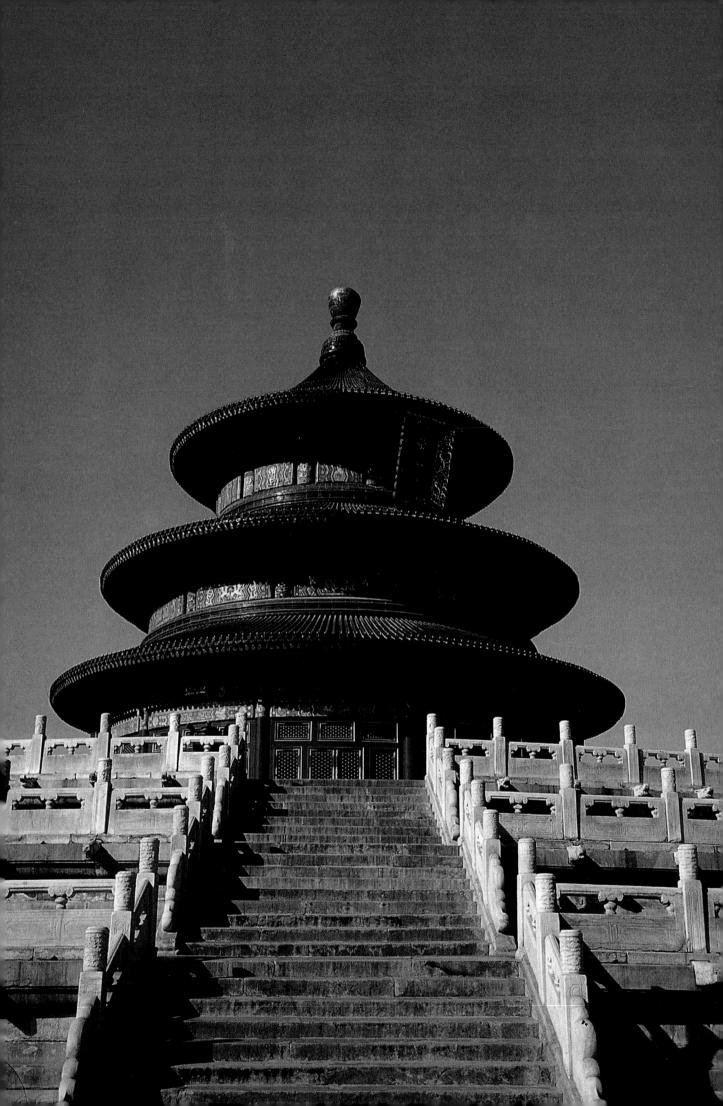

TRADITION AND INNOVATION

With no fixed rules for succession, continued in-fighting among contenders for the Yuan throne helped to hasten the fall of Mongol rule after less than a hundred years. Inept rule, combined with disastrous droughts and famines, inspired peasant rebellions throughout China. The overthrow of the Mongols would ultimately lead to almost three centuries of native rule.

Ming Dynasty (1368 – 1644)

The Ming (literally, "brilliant") dynasty was founded in 1368 by General Zhu Yuanzhang, a peasant-born native Chinese who took the imperial name of Hongwu and reigned with an iron fist for thirty years. The Hongwu emperor moved his capital to Nanjing and changed the name of the Yuan winter capital to Beijing (literally, "the north pacified"). Rejecting the ideals of the discredited Song dynasty, the new emperor looked back to the Tang dynasty as his model for rebuilding a unified China. While the conservative new regime was able to reestablish a strong and stable bureaucracy, the Hongwu emperor's anti-intellectual leanings were manifested in fierce purges that rapidly depleted the ranks of the literati; nevertheless, the arts flourished under the patronage of subsequent Ming emperors during nearly three centuries of economic prosperity.

In 1407, the Yongle emperor began a massive construction program to rebuild the new capital at Beijing. Hundreds of thousands of workers labored for fourteen years to build the fabulous city, including the circular Temple of Heaven, envisioned by the emperor and his architects. Then as now, Beijing was divided into two rectangular areas aligned along a north-south axis: a southern Outer City and a northern Inner City. Within the Inner City is the rectangular Imperial City, which is entered from the south through the Gate of Heavenly Peace (Tian An Men). Inside the Imperial City stands the square, walled enclosure known as the Forbidden City. Within these walls is a large courtyard containing three south-facing ceremonial halls, the largest of which is the Hall of Supreme Harmony, the audience hall in which celebrations for the new year, the winter solstice, and the emperor's birthday were held. Behind the main halls are the palaces that served as the personal living quarters of the imperial family. Surrounding these palaces are various government offices, a theater, and a magnificent garden originally intended for the exclusive use of the Emperor and his family.

The arts thrived under the patronage of the Xuande emperor, who ruled from 1426 to 1435. A talented artist and poet, the emperor gathered many of China's finest artists to his court in Beijing and awarded them honors and titles. As court painters, however, these artists were required to adhere to rigid regulations and to follow the conservative conventions of Southern Song and early Yuan painting styles. Artists of the Ming court produced narrative figure paintings, bird and flower paintings, and landscapes in the style of the Ma-Xia school that were commissioned by the emperor to glorify the Ming dynasty. Painters who preferred the style of the Yuan dynasty literati over the conservative style of the court were unable to reap the benefits of imperial patronage.

Temple of Heaven

Beijing, Ming dynasty; wood, painted and gilded with tiled roof; 15th-century foundation, restored after fire in 19th century. Photograph by Dennis Cox, ChinaStock.
This three-tiered circular building, with its magnificent blue-tiled roof and brilliantly painted woodwork, is part of the 700-acre Temple of Heaven complex to which the emperor returned each year at dawn on the winter solstice to renew his mandate from heaven.

**Hall of
Supreme Harmony**

Ming dynasty and after;

Forbidden City, Beijing.

Werner Forman Archive/

Art Resource, New York.

Built in the fifteenth
century, this magnificent
hall, which is elevated
above all other buildings
in the Forbidden City,
has been restored many
times over the centuries.
Approximately 200 feet
long and 120 feet tall
(61 x 36.6 meters), it
rests on a three-tiered
terrace, each tier
surrounded by a white
marble balustrade.

The Zhe school, named for Zhejiang province, represented a conservative style of landscape painting modeled on the Ma-Xia style of the professional and court painters, albeit with more narrative detail and less mannered brushwork. Its founder was Dai Jin (1388–1462), who served at the court for several years before losing favor with the emperor and returning home to Hangzhou. Dai Jin's rapid, vigorous brushwork is evident in his famous handscroll entitled *Fishermen on the River*. This painting shows Dai

Jin's work at its least academic, using an almost cartoonlike style based on the work of the literati painter Wu Zhen, one of the Four Great Masters of the late Yuan period.

The Wu school (named for the Wu district around Suzhou in southeast China) reestablished the literati tradition as the dominant force in Chinese painting. Shen Zhou (1427–1509), the founder of the school, was born into a wealthy, Confucian family in Suzhou. Talented as a calligrapher, poet, and painter, the prolific Shen Zhou

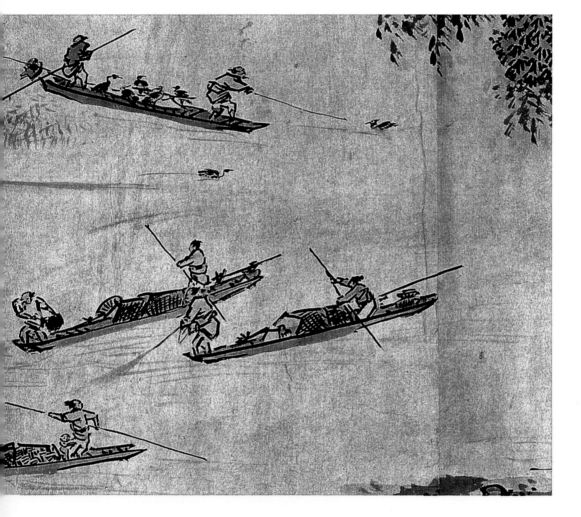

Fishermen on the River

DAI JIN, Ming dynasty; detail from a handscroll: ink and color on paper;
18⅛ in. high (46 cm). Freer Gallery of Art, Smithsonian Institution, Washington, D.C.

An exceptional painter who worked in both the professional
and literati traditions, Dai Jin is renowned for his distinctive rapid
brushwork and his use of warm and cool tinted inks. His spontaneous
brushwork lends a sketchy feeling to this lively narrative painting.

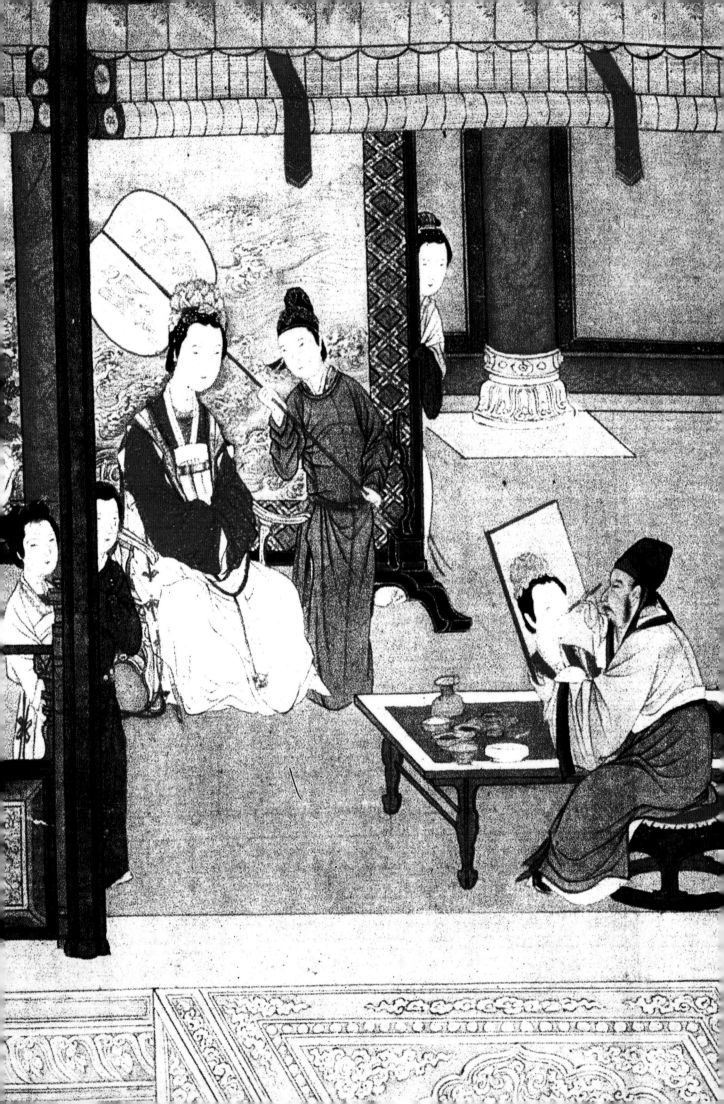

chose not to pursue an official career. His bold compositions, masterful brushwork, and disdain for making pretty pictures reflect his admiration for the late Yuan masters whom he diligently studied. In *A Poet on a Mountain*, Shen Zhou depicted a man (probably himself) gazing down from atop a steep cliff. According to the poem at the top of the album leaf, the poet in the painting is listening to the sound of a flute. The literati painters considered the poems and calligraphy that complemented their paintings to be no less important than the images they accompanied.

Wen Zhengming (1470–1559), the most prominent of Shen Zhou's pupils, did not start painting until he was sixty years old. His paintings, which show a more lyrical approach to the use of color than those of Shen Zhou, included landscapes, figure paintings, and ink paintings of bamboo. Gnarled cypress and cedar trees were recurring motifs in Wen Zhengming's landscapes. The relatively flat, tight mass of contorted calligraphic forms in his paintings often resulted in complex surface patterns reminiscent of the late Yuan master Wang Meng. The subtle and dignified styles of Shen Zhou and Wen Zhengming set the standards for literati painting until the creative momentum of the Wu school began to subside at the end of the sixteenth century.

Another group of painters, whose style was more refined than that of the professional painters but more technically advanced than that of the literati, were working near Suzhou around the same time. Qiu Ying was a professional painter who was neither scholar, poet, nor calligrapher. Through his association with the literati, Qiu Ying was able to gain access to private collections in order to study the works of Tang, Song, and Yuan masters. His own paintings demonstrate his remarkable ability to work in the various styles of these earlier periods. While the figures in Qiu

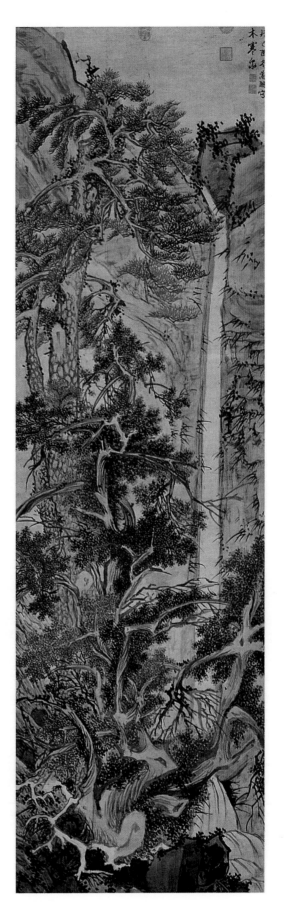

Spring Morning in the Han Palace

detail; QUI YING, Ming dynasty; section of a handscroll: ink and colors on silk. National Palace Museum, Taibei.
Qiu Ying's study of Song ceramics and ancient bronzes enabled him to include extremely accurate depictions of these objects in his paintings.

Poet on a Mountain

SHEN ZHOU, Ming dynasty; one of six album leaves mounted as a handscroll: ink and light color on paper; 15¼ x 23¾ in. (38.7 x 60.2 cm). Purchase: Nelson Trust, The Nelson-Atkins Museum of Art, Kansas City, Missouri.
Shen Zhou's paintings often included an image of the artist as an old man walking with a staff. The wistful mood of this intimate painting, executed with thick, rapid brushstrokes and even-toned washes, befits the ideal Confucian scholar living in seclusion and contemplating nature.

Old Trees by a Cold Waterfall

WEN ZHENGMING, dated 1549, Ming dynasty; hanging scroll: ink and colors on silk; 76¼ x 23¼ in. (193.6 x 59 cm). National Palace Museum, Taibei.
This densely painted composition is visually unified by the narrow, ribbon-like waterfall that runs vertically down the center of the large hanging scroll. The gnarled old trees represent endurance in the face of hardship—an ideal of the Confucian gentleman—as well as the artist's personal response to aging.

白雲如帶束山腰
石磴飛空細路遙
獨倚杖藜舒眺望
欲因鳴澗答吹簫
沈周

Ying's paintings are not as naturalistic or individualized as those portrayed by the Tang masters, his elegant brushwork and brilliant use of color helped earn him recognition as one of the four Masters of Suzhou.

The Ming period was characterized by an intense interest in art theory and criticism. The most influential theorist in Chinese art history was Dong Qichang (1555–1636), a painter, calligrapher, and scholar who served as a high official in the Ming court. Dong distinguished between the "northern school" of painting—in which he included the Zhe school and the professional artists of the Ma-Xia tradition—and the "southern school," in which he included painters working in the literati tradition. Dong's use of the terms "northern" and "southern" were not geographical designations; rather, they alluded by analogy to the

northern and southern schools of Chan Buddhism during the Tang dynasty. Dong dismissed paintings of the northern school as superficial, decorative works that relied upon painterly effects and excessive detail while slavishly adhering to court dictates and imitation of the past. At the same time, he glorified the literati tradition of the "southern school," which he traced back to the Tang dynasty painter Wang Wei, tenth-century landscape painters Ju-Ran, Fan Kuan, and Guo Xi, and the Four Great Masters of the Yuan.

Rejecting slickness and sentimentality, Dong Qichang called on painters to use brushwork to express personal insights in their paintings rather than strive to capture formal likenesses. Although Dong Qichang's own painting style was based on Yuan conventions, his expressionistic landscape compositions reorganized landscape elements and

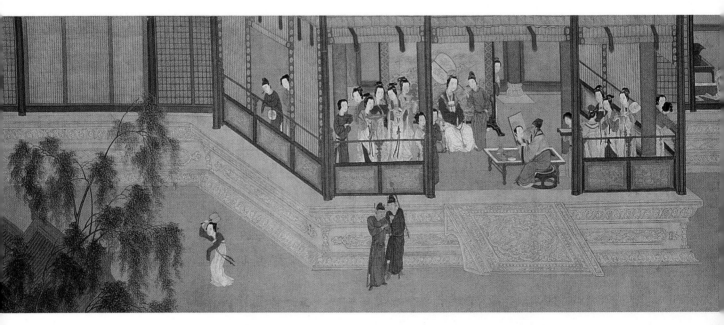

Spring Morning in the Han Palace

Qui Ying, Ming dynasty; section of a handscroll: ink and colors
on silk; 12 in. high (30. 4 cm). National Palace Museum, Taibei.
This charming work depicts a court painter, perhaps Qui
Ying himself, who is painting a portrait of an empress or
imperial concubine surrounded by attendants and two palace
eunuch guards. His allusions to the Tang dynasty figure style
reflect his familiarity with earlier Chinese painting styles.

Landscape After Wang Meng

DONG QICHANG, Ming dynasty; album leaf: ink and color on paper; 24½ x 16 in. (62.3 x 40.6 cm). Purchase: acquired through the generosity of the Hall Family Foundations and the exchange of other Trust properties, The Nelson-Atkins Museum of Art, Kansas City, Missouri.

Dong Qichang rejected both formal realism and the direct imitation of Old Masters. Although his manipulated landscape elements are based on observation of the natural world, the resulting abstract, rhythmic patterns on the surface of his paintings deny the illusion of three-dimensional space.

Jar

Ming dynasty, mark and reign of Jiajing (1522–66); porcelain painted in underglaze blue and overglaze polychrome enamels; 9 1/8 in. High 23.1 cm). Rogers Fund, 1917, The Metropolitan Museum of Art, New York.
This charming example of five-color decoration features the popular fish-among-water-weeds motif. Because the Chinese word for "fish" sounds very much like the word for "abundance," the depiction of fish is a visual pun that symbolizes the desire for prosperity.

distorted spatial relations in a more arbitrary and abstract manner. The theories set forth by Dong Qichang, as well as his distinctive landscape painting, laid the groundwork for the individualist painters who followed.

Ceramic production flourished under imperial patronage during the Ming dynasty; indeed, the term "Ming vase" has become almost synonymous in many Westerner's minds with any ceramic vase made in China prior to the twentieth century. Elegant white porcelain wares with transparent glazes, blue-and-white wares, and monochrome wares were produced in vast numbers at the beginning of the fifteenth century—several centuries before white porcelain would be produced in Europe. The Yuan technique of painting under

the glaze with cobalt blue was perfected around this time, resulting in the production of magnificent wares characterized by their rich color and clarity of drawing.

With the perfection of overglaze enamel colors in the mid-fifteenth century, five color (*wucai*) enamels—a combination of underglaze blue and overglaze polychrome enamels—became the standard decorative ware of the late Ming period. The decoration of these wares was made by painting cobalt blue pigment under the glaze and firing at a high temperature before adding bright enamel colors on top of the glaze and refiring at a lower temperature. Monochrome glazed wares, especially monochrome blue, monochrome yellow, and white *blanc de Chine* wares were also very popular.

Jar with Dragon

Ming dynasty, reign of Xuande (1425–35); porcelain painted in underglaze blue; 19 in. high (48.3 cm). Gift of Robert E. Tod, 1937, The Metropolitan Museum of Art, New York.
The fierce but graceful dragon on this jar reflects the high standards of early fifteenth-century brushwork. The dragon, which has served as a symbol of the Chinese emperor since ancient times, appears in nearly all the arts commissioned by the Ming court.

Incense Burner

Ming dynasty, reign of Xuande (1426–35); cloisonné enamel; 4¾ in. high x 4⅜ in. diameter (12 x 11.1 cm). National Palace Museum, Taibei. The surface of this incense burner with dragon handles is covered with a lotus scroll design. Chinese cloisonné enamel vessels often borrowed decorative motifs and shapes from contemporary ceramic and lacquer wares as well as from bronze ritual vessels.

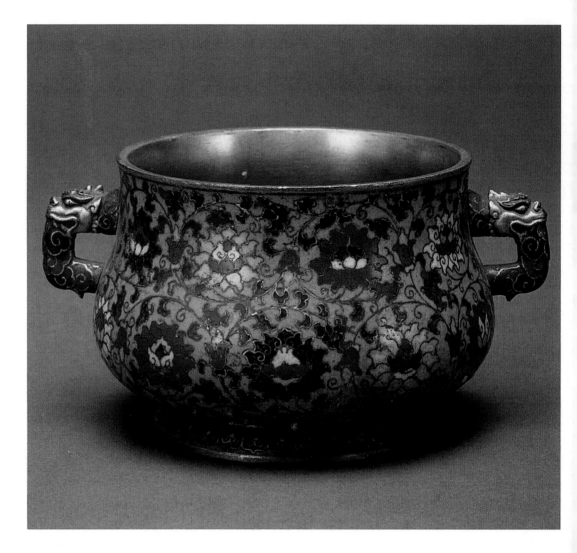

Box

Ming dynasty, dated 1600; painted lacquer; 27¾ in. long (71.1 cm). Victoria and Albert Museum, London. The colorful, painted decoration on the cover of this cinnabar-red lacquer scroll box depicts a legendary archery competition at the Tang court while the inside depicts a moonlit riverbank with exotic birds. The sides of the box are made of decorative basketwork.

Lacquered objects of extremely high quality—including cinnabar, painted, incised, and gilded wares—were also produced under imperial patronage. Lacquer is an excellent preservative and provides a smooth, lustrous surface for the application of painted decoration. Like porcelain and silk, lacquer is a Chinese invention, but it did not become popular in the West until the late seventeenth century.

The earliest known Chinese cloisonné enamel wares were produced during the reign of the Xuande emperor, although a few pieces have been tentatively dated to the Yuan dynasty. Cloisonné metalwork was made by applying colored enamel pastes into enclosures, or "cloisons," produced by applying shaped metal strips to a cast copper or bronze base and then firing at a relatively low temperature to melt the enamels. After firing, the vessel would be polished to form a smooth surface that was level with the edges of the enclosures. The exposed cloison edges were then usually gilded. Cloisonné was adapted from a Western technique introduced to China during the Yuan dynasty, although Byzantine cloisonné was usually applied to a base of gold rather than copper or bronze. Initially considered aesthetically unacceptable by Chinese connoisseurs because of its bright metallic colors, cloisonné began to be used in the fifteenth century for utilitarian objects for the court and ritual objects for temples.

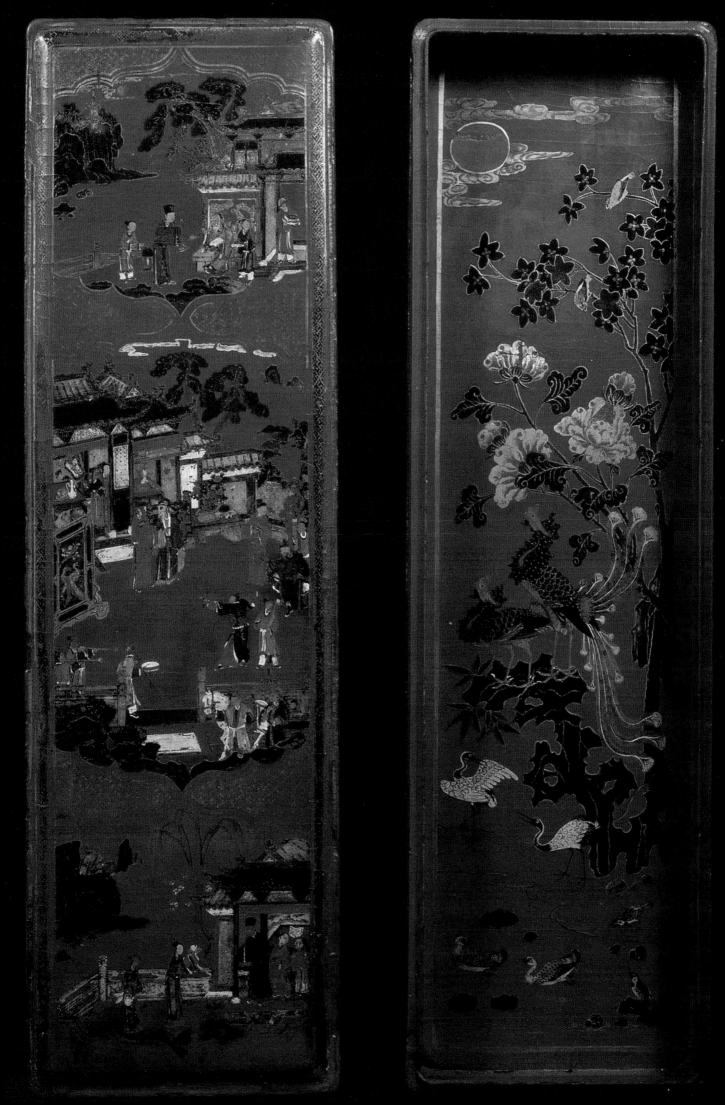

Landscapes and Flowers

YUN SHOUPING, dated 1672, Qing dynasty; detail from album leaf: ink and color on paper; 11¼ x 17 in. (28.5 x 43.1 cm). National Palace Museum, Taibei.

Yun Shouping was a master of the flower-painting genre. These peonies were painted in the "boneless" style, first used during the Northern Song period, in which color washes are used without ink outlines.

Qing Dynasty (1644 – 1912)

By the late sixteenth century, political corruption was rampant under the incompetent rule of the last Ming emperors. In 1644, Manchurian tribesmen invaded Beijing and brought China under the control of the Qing (literally, "pure") dynasty. Unlike the Mongol rulers in the fourteenth century, the Manchus genuinely admired Chinese art and culture. The new regime immediately adopted Chinese administrative institutions and encouraged Chinese scholars to take an active role in government service. Scholarly projects were undertaken to preserve Chinese language and culture, a painting bureau was established, and official craft workshops were set up in the Forbidden City for weaving, enamels, glass, porcelain, and the carving of ivory and jade.

China prospered under the first 150 years of Qing rule. Art and scholarship thrived during the long and benevolent reigns of the Kangxi emperor (1662–1722) and his grandson, the Qianlong emperor (1736–95), and most Chinese readily accepted the benevolent rule of their foreign conquerors. The Qing emperors embellished the capital at Beijing with impressive new buildings in brick, glazed tiling, and stone. Contact with the Western world steadily increased under the Qing, first through Christian missionaries and, later, through traders from the European colonial powers.

Distinctions of rank and status were expressed symbolically in the Qing court by costume and insignia. The exquisite Manchu dragon robe was the standard attire for members of the court. The full-length, side-fastening silk robes were embroidered with four-clawed dragons and other symbols. Most dragon robes were blue, although some were brown, turquoise, or red. The emperor and some of his highest-ranking princes wore robes with a five-clawed dragon, but the emperor alone was permitted to wear a robe of bright yellow.

Although the Qing court continued to support an imperial painting academy, the most important paintings of the period came from the literati tradition, which split into two distinct schools early in the Qing dynasty. The orthodox school included highly skilled scholar-painters with a complex vocabulary of brushstrokes who were interested in preserving the painting styles of the old masters, especially those of the Yuan dynasty. Wang Shimin, one of the Six Great Orthodox Masters of the early Qing period and oldest of the Four Wangs (Wang Shimin, Wang Jian, Wang Hui, and Wang Yuanqi),

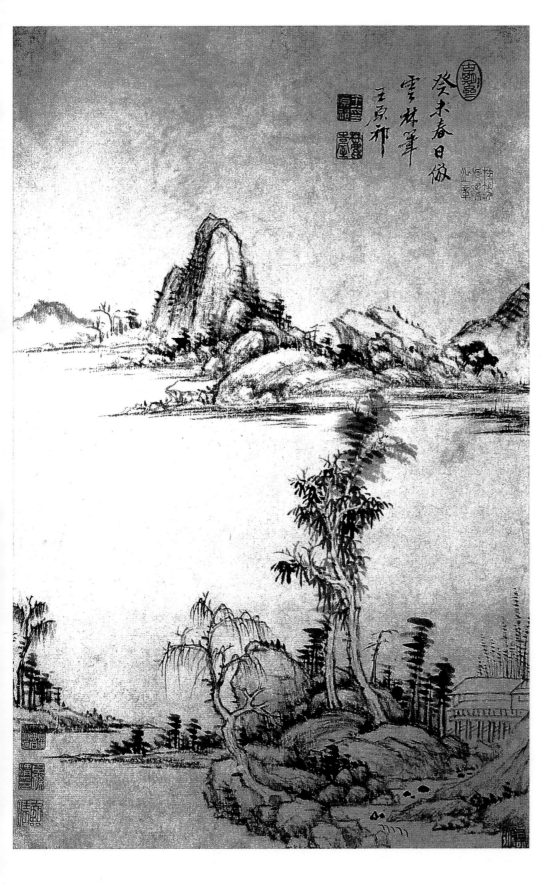

Landscape

*Wang Yuanqi; Qing dynasty;
ink and light color on paper.
Musée Guimet, Paris.*

The Orthodox painters
of the eighteenth century
painted abstracted land-
scapes in the manner
of Yuan dynasty painters
who, in turn, modeled
their paintings on those
of the still earlier Tang
dynasty. Wang Yuanqi
was the youngest and
most original of the
Four Wangs who painted
in this conservative style.

was a pupil of the late Ming painter and art critic Dong Qichang, whose theories were greatly admired by the orthodox painters. Another of the Orthodox masters, Yun Shouping, is best known for his brilliantly colored flower paintings in which he revived the Northern Song "boneless" technique of painting in color washes without black ink outlines. Despite the familiar look of their compositions, which were clearly based on the styles and brushwork of earlier painting masters, the superb technique of the orthodox masters was greatly admired by the Qing court.

The literati individualist painters developed a more innovative style that was less reliant on the styles of past masters. Unlike the orthodox painters, who chose to live quietly at home or else accepted positions at the court, the most famous of the individualist painters, known collectively as the Four Monks, responded to the Manchu takeover by retiring into Buddhist and Daoist Temples. They preferred to stay in close contact with nature and use their paintings to express their own personal visions.

Dao-Ji (1642–1707) symbolically expressed the philosophy of the individualist painters when he wrote : "The beards and eyebrows of the ancients do not grow on my face." Using exuberant, almost abstract brushwork to reflect the inner vitality of

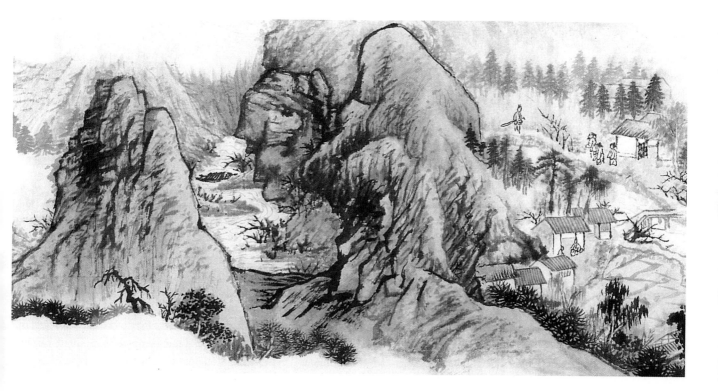

The Bao'en Temple

KUN-CAN, dated 1664, Qing dynasty; hanging scroll: ink and color on paper; 52½ in. high (133.3 cm). Sen'oku Hakkokan (Sumitomo Collection), Kyoto.
This dense composition, with its complicated brushwork and strongly contrasting ink tones, is complemented by the sunlit hills depicted in softly colored washes in the distance. The temple complex in the painting is the Buddhist temple in Nanjing at which Kun-can served as abbot.

The Peach Blossom Spring

DAO-JI, Qing dynasty; section of a handscroll: ink and colors on paper; 9⅞ in. high (25 cm). Freer Gallery of Art, Smithsonian Institution, Washington, D.C.
The painting illustrates a fourth-century poem that tells of a fisherman's accidental discovery of an unspoiled paradise that had been shut off from civilization's corrupting influence for centuries. Dao-Ji's atmospheric composition combines ink washes with densely layered brushwork to evoke a world of mystery and wonder.

Three Objects for the Writing Table

Qing dynasty, mark and reign of Kangxi (1661–1722); porcelain with clair de lune glaze; water coupe 4¹⁄₁₆ in. diameter (10.5 cm), vase 6¼ in. high (15.9 cm), brush washer 4⁹⁄₁₆ diameter (11.7 cm). Gift of Edwin C. Vogel, 1966; Bequest of Mary Stillman Harkness, 1950; Gift of Edwin C. Vogel, 1964—The Metropolitan Museum of Art, New York.

The pale blue *clair de lune* glaze is among the most widely admired of Qing dynasty glazes. The three beautiful and functional objects shown here are sheathed in this delicate moonlight glaze.

An Autumn Scene

Hua Yan, dated 1729, Qing dynasty; album leaf: ink and light color on paper; 9 x 6⅜ in. (22.8 x 16.1 cm). Freer Gallery of Art, Smithsonian Institution, Washington, D.C.

Gentler in effect than the paintings of the other eighteenth-century eccentrics, Hua Yan's depiction of a scholar gazing across the water is playfully distorted. The artist's abbreviated style was criticized by a contemporary for "leaving out too much."

the mountains depicted in his landscapes, Dao-Ji often added blue and pink washes or texture strokes in the form of dots to his paintings. Color was also used to great effect by the monk-painter Kun-can, who was an abbot of the Bao'en temple that is depicted in his famous landscape in which colored ink washes were used to depict distant mountains.

Under the patronage of wealthy local merchants, a group of eighteenth-century painters known as the Eight Eccentrics of Yangzhou developed their own highly idiosyncratic styles of painting. These included the rough style of Gao Qipei (c. 1672–1734), who sometimes painted with his fingers and nails, the deliberate amateurism of Jin Nong (1687–c. 1764), and the playful, delicate style of the animal and landscape painter Hua Yan (1682–1756).

Western art was a source of fascination for the Qing court in the eighteenth century. The Italian-born Jesuit priest Giuseppe Castiglione (1688–1768), known in China as Lang Shi'ning, spent the last fifty years of his life painting at the imperial court and training Chinese artists in western techniques. His hybrid painting style combined traditional Chinese watercolor techniques with European perspective and chiaroscuro.

A wide variety of superb ceramics were produced at the imperial kilns at Jingdezhen during the Qing dynasty. A century of excellence began in 1683 when the Kangxi emperor appointed trained officials to be on-site supervisors of the imperial kilns. Chinese ceramics were in great demand in Europe in the eighteenth century. At the same time, foreign novelties were of great interest to the Chinese. Qing potters drew inspiration not only from earlier periods in Chinese history but from European decorative styles as well. While ceramics incorporating European design elements were occasionally made for the emperor, porcelain wares intended for imperial use were usually far more restrained in design than the flamboyantly decorated ceramics made for the export market.

Developments in the technology of overglaze enamel porcelain, in which colored glazes are

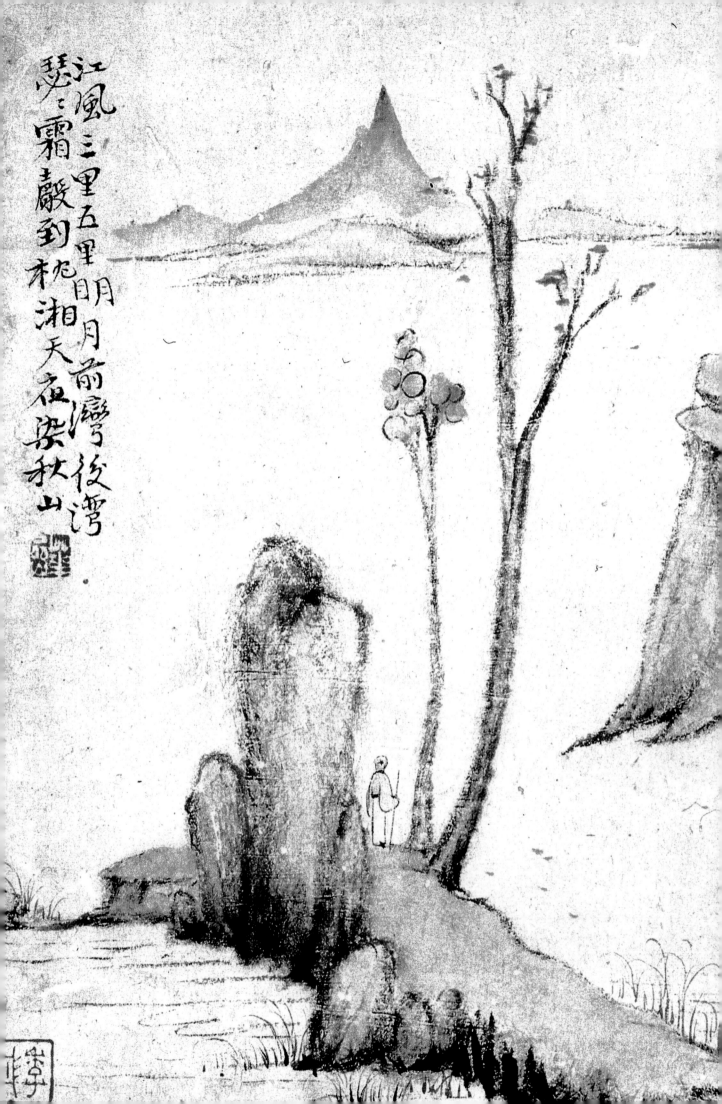

江風三里五里明月前灣後灣
瑟瑟霜嚴到枕湘天夜梁秋山

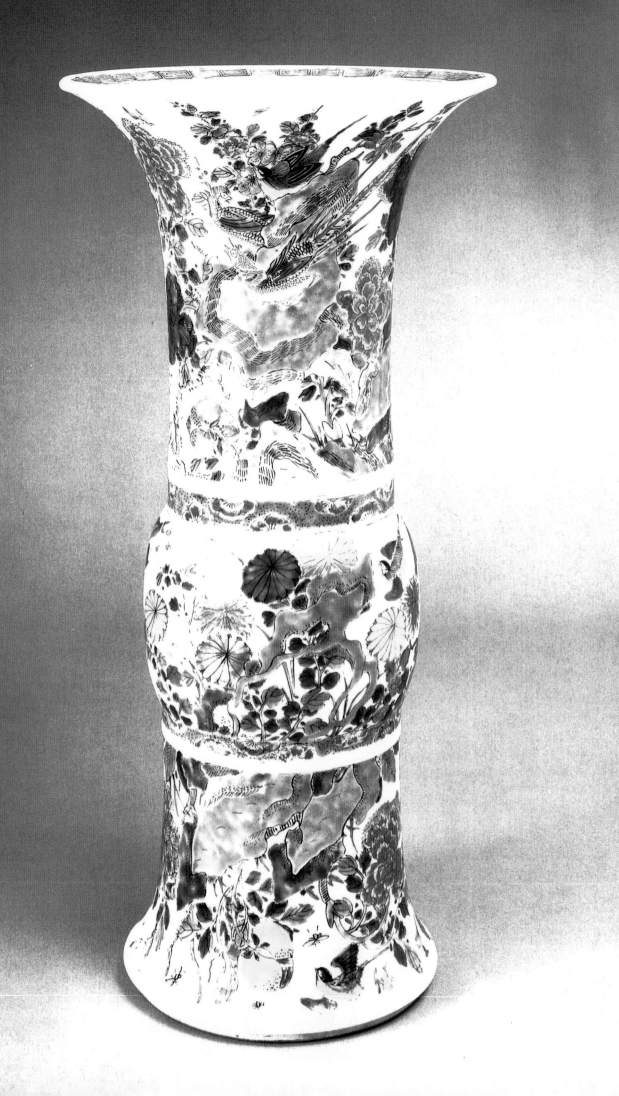

applied over the glaze before a second firing, led to the production of beautiful *famille verte* and *famille rose* enamel-decorated wares. *Famille verte* porcelains were painted with colored enamels in which several distinctive shades of green predominate, while the *famille rose* palette featured delicate pink tones derived from colloidal gold. Both were exported to Europe in great numbers, as were the extremely popular underglaze blue-and-white wares.

Monochrome-glazed porcelains were also produced in a wide variety of distinctive colors.

The popularity of single-color glazed porcelains is reflected in the seemingly endless number of new shades that appeared at this time. Many of these imperial wares were used for ceremonial purposes. Others, such as the rose-colored peachloom glaze wares that were produced in a limited range of forms, including water droppers and brush rests, were intended primarily for the scholar's table. Porcelains with the pale-blue *clair de lune*, or "moonlight," glaze are among the most beautiful ceramics made during the Kangxi reign.

Following page:

Bowl with Clouds, Lotuses, and "Long Life" Characters

Produced at the imperial glass studios in Beijing, Qing dynasty, mark and reign of Yongzheng (1722–35); pale blue clear glass with wheel-engraved designs; 6⅞ in. diameter (17.4 cm). Asian Art Museum, San Francisco.
Used in Buddhist rituals, this bowl is decorated with lotus flowers and the Chinese character for long life to symbolize the endurance of Buddhist teachings. The techniques used to make and decorate this distinctive bowl were influenced by the Venetian-style European glass imported into China in the early eighteenth century.

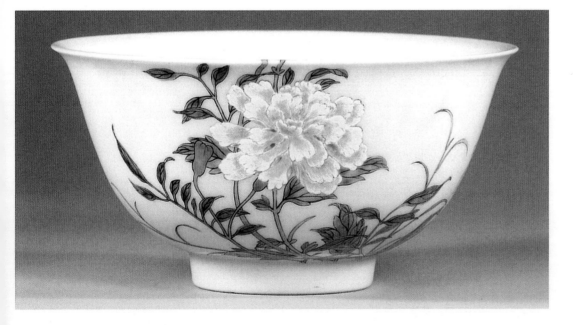

Bowl

Qing dynasty, mark and reign of Yongzheng (1722–35); porcelain painted in overglaze polychrome enamels (famille rose); 4⁷⁄₁₆ in. diameter (11.2 cm). Alfred W. Hoyt Collection, Bequest of Rosina H. Hoppin, 1965, The Metropolitan Museum of Art, New York.
Admired for their soft rose coloration, the finest *famille rose* porcelains of this period were made for the exclusive use of the emperor and his court. The design on this elegant bowl begins on the outside, continues over the rim, and is completed on the inner surface.

Vase

Qing dynasty, probably Kangxi period (1661–1722); porcelain painted in overglaze enamels (famille verte) and gilt; 18 in. high (45.7 cm). Bequest of John D. Rockefeller, Jr., 1960, The Metropolitan Museum of Art, New York.
Brightly colored with distinctive green tones, *famille verte* enamels are thickly applied over darker outlines and details. This beaker-shaped vase is decorated with a lively pattern of birds, rocks, and flowers.

Duck and Drake

*Qing dynasty, Qianlong
period (1736–95); white
jade, Private collection.*
The pairing of duck and
drake, which mate for
life, was symbolic of do-
mestic bliss and marital
harmony. Decorative
carvings such as this
were often used as orna-
ments or paperweights.

Glass production began to flourish in 1696 after
the Kangxi emperor set up a glass studio within the
Imperial Workshop at Beijing. Used mostly for
Buddhist ritual objects until the Ming dynasty,
glass was never as popular in China as porcelain,
lacquer, and jade. Glass vessels, decorated by incis-
ing, carving, molding, enameling, diamond-point
engraving, or overlay (cameo glass), were often
modeled after ceramic, jade, lacquer, and bronze
vessels. During the Qing dynasty, glass was used
for bowls, snuff bottles, lanterns, window panes,
and scientific instruments as well as for imitation
gemstones to be used in jewelry and hairpins.
Enameled decoration was sometimes applied to
opaque white glass in imitation of porcelain. In
the late nineteenth century, a revived interest in
the decorative arts led to an increase in the pro-
duction of ornate lacquer wares, ivory carvings,
textiles, and jewelry.

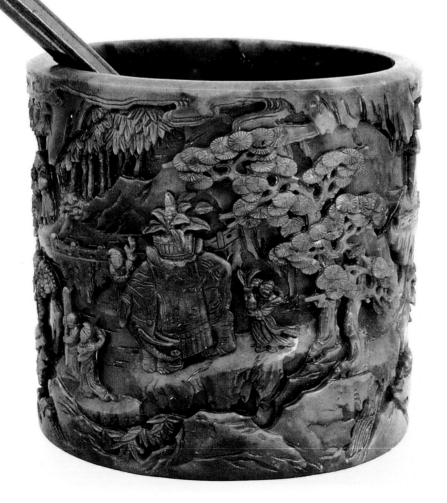

**Scholar's Brush
Holder and Brush**

*Qing dynasty, Qianlong period
(1736–95); mottled green
jade (nephrite); 6 in. high
(15.2 cm). Gift of Herbert R.
Bishop, 1902, The Metropolitan
Museum of Art, New York.*
In the continuous scene
carved deeply into the
outside of this jade brush
holder, Daoist sages and
their attendants inhabit
a stylized landscape.

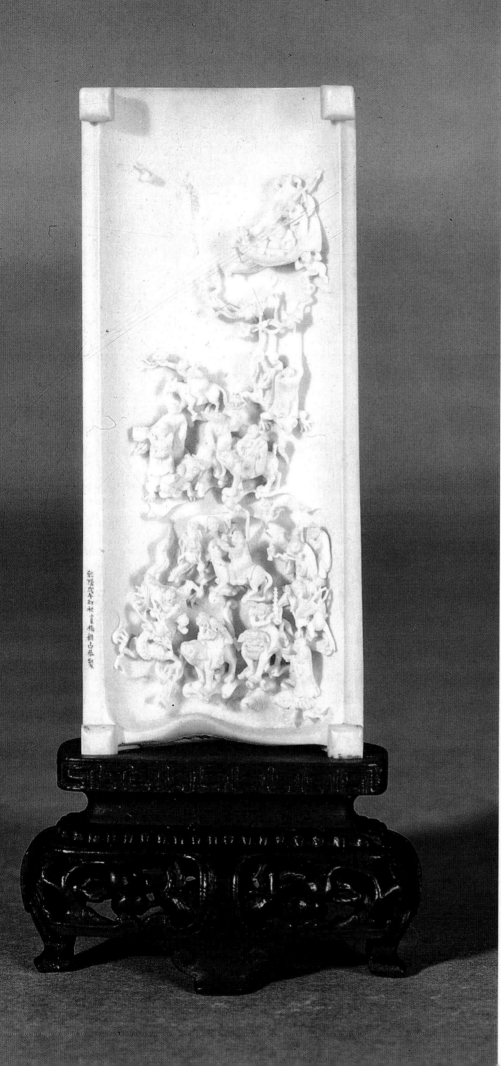

**Carved Ivory
Miniature**

*HUANG ZHENXIAO, dated 1739,
Qing dynasty, Qianlong period
(1735–95); carved ivory;
3⅝ in. high (9.2 cm). National
Palace Museum, Taibei.*
Paintings often served
as a source of inspiration
for Chinese artists work-
ing in other media. This
ivory wrist rest from a
scholar's desk was later
mounted as a table screen.

The Twentieth Century

A long string of military, political, environmental, and economic disasters led to the collapse of the Qing dynasty in 1911. The imperial government was replaced by the new Republic of China under the leadership of Sun Yat-sen's Nationalist Party. The new government was determined to modernize China by adopting Western ideas and ways. The Shanghai Fine Art Institute, founded in 1912, introduced art students to such Western techniques as drawing from life, painting arranged still lifes, painting in oil on canvas, and using watercolor and gouache on nonabsorbent paper. While some artists resisted westernization by reasserting traditional Chinese painting styles, many others traveled to Japan and Europe, especially Paris, to study Western art. By the end of the First World War, schools of modern art had opened in Beijing, Shanghai, Nanjing, and Hangzhou, and an interesting amalgam of Chinese and Western styles began to evolve. Despite the growing interest among Chinese painters in European-style brushwork, color, perspective, and abstraction, however, Chinese decorative arts were largely unaffected by Western influence.

The Japanese attack on Beijing in 1937 left many Chinese artists disillusioned with their weak and corrupt government. Some fled from the big cities to discover anew the beauty of the Chinese landscape. Others used their talents to create political cartoons, posters, and woodblock prints to help publicize the kind of radical social and political change advocated by China's growing Communist Party. As the Second World War raged, valuable artworks were moved for safety from the Palace Museum, which had been founded in Beijing in 1925 to house the imperial art collection, to a new Palace Museum in Taiwan.

The Second World War had barely come to an end when China was plunged into civil war. With the establishment of the People's Republic of China by the Communists in 1949, the Nationalists retreated to the island of Taiwan. There, some artists continued to work in traditional Chinese styles while others developed a synthesis of traditional Chinese and Western techniques. On the mainland, Mao Zedong's denouncement of art for art's sake and his declaration that art must serve to educate and inspire the masses had transformed the once-revered literati into "stinking intellectuals." Painting styles in the People's Republic became intrinsically linked to political and ideological trends.

In the 1950s, three approaches to painting vied for official recognition: the traditional Chinese style, the "socialist-realism" of the Soviet Union, and a synthesis of Western and Chinese styles. "Revolutionary romanticism," "lyrical art," and "heroic art" each took its turn as the officially sanctioned painting style in China. During the Cultural Revolution (1966–76), universities, art schools, and museums were shut down, and "counter-revolutionary" artists and scholars were put in prison or exiled to rural communes to be "re-educated" according to Communist Party ideology.

During the past fifty years, many Chinese artists have chosen to live and work outside of mainland China, especially in Taiwan, Hong Kong, Singapore, Southeast Asia, Hawaii, and major cities in Europe and the United States. The painters Zeng Shanqing (1932–) and Yang Yanping (1934–) are a married couple who came to the United States in 1986. Zeng Shanqing was a professor of art at the Central Academy of Fine Art in Beijing until he was forced to spend several years at hard labor in the countryside during the Cultural Revolution. He specializes in the time-honored subjects of figure painting and the painting of horses and is especially interested in portraying the downtrodden people of Tibet. Although Yang Yanping escaped physical hardship during the Cultural Revolution, she was obliged to spend those years painting large oil paintings of Mao Zedong and glorified depictions of workers and peasants. In the landscapes, lotus paintings, and abstracted, calligraphic compositions she has painted since the end of the Cultural Revolution, Yang has reinterpreted traditional subject matter in a manner uniquely her own. Both artists have made it abundantly clear that they share the belief of the scholar-painters who came before them that the purpose of painting is not to formally represent the natural world but, rather, to express the heart of the artist.

The Cultural Revolution came to an end with the death of Mao Zedong in 1976. Since that time, the freedom of expression allowed to artists by the Chinese government has waxed and waned at the whim of the ruling bureaucracy. With the death of Deng Xiaoping in 1997, a new generation takes over the reins of government as China enters the twenty-first century. What impact this will have on the future of Chinese art remains to be seen. In the end, the past half-century of Communist rule will inevitably take its place as one more scene on the ever-unrolling scroll of Chinese history.

Praying

ZENG SHANQING, dated 1992;
ink and colors on rice paper;
71 x 38 in. (180.3 x 96.5 cm).
British Museum, London.
Zeng Shanqing depicts
a group of Tibetans at
prayer. Viewed from behind,
the gesture of the central
figure serves to draw the
viewer's eye upward. Form
and color are effectively
used to evoke the dignity
that underlies the hardship
of the people's daily lives.

Autumn Lotus Pond

YANG YANPING, dated 1985;
ink and colors on paper;
37⅜ x 70¼ in. (96 x 180 cm).
British Museum, London.
Painting the pond in autumn when the lotus stalks are bent and the flowers are already past their prime, Yang Yanping skillfully depicts a uniquely unconventional view of a flower that is traditionally painted at the height of its beauty.

INDEX